CREATIVE GREETING CARDS

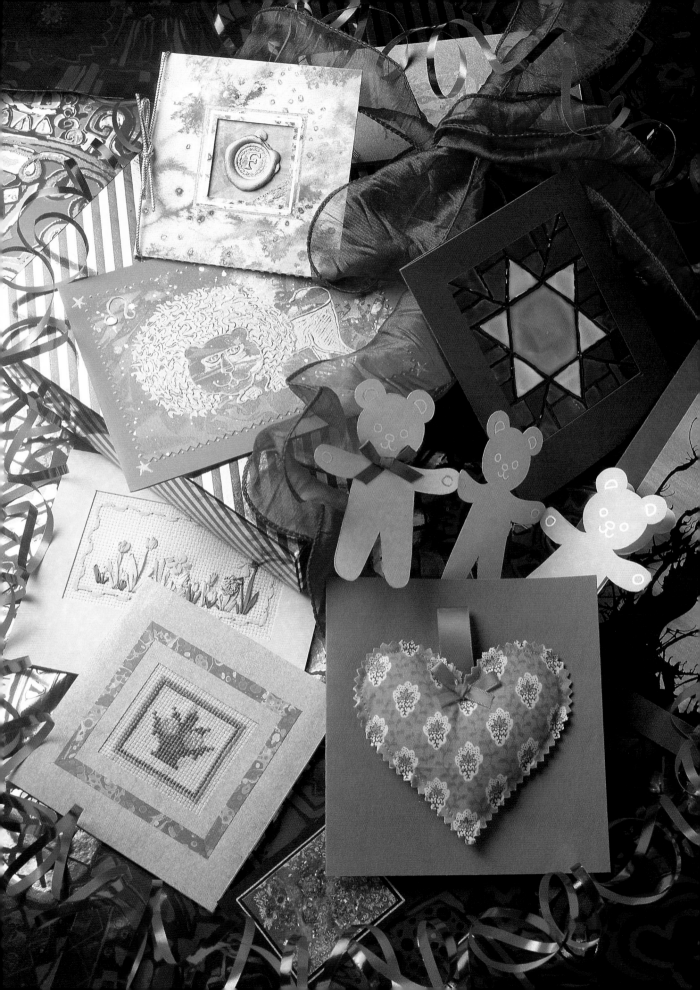

CREATIVE GREETING CARDS

PERSONALIZED PROJECTS FOR ALL OCCASIONS

CAROLINE GREEN

THE READER'S DIGEST ASSOCIATION, INC.
Pleasantville, New York / Montreal

Acknowledgments and Suppliers

Many thanks for the baby cards originally featured in *Pregnancy and Birth* magazine, and many thanks, also, for the fabric collage and stamped Christmas cards originally featured in *Jane Asher's Christmas Special*, and the work of art cards featured in *Homestyle* magazine.
The following items were supplied by:

Philip and Tacey – Pebeo products.

Stamp It for Fun! – stamps, embossing powders (various colors and metallic), stamp pads, and slow-drying embossing inks.

English Stamp Company – rubber stamps, inks, rollers, etc.

For relief outliners, silk paints, and relief paint (gutta): Pebeo Canada, 1905 rue Roy, Sherbrooke QC, J1K 2X5, Canada; tel. (819) 829-5012.

For edible paper: Walter Molzahn & Co. Inc., 1050 W. Fullerton Avenue, Chicago, IL 60614; tel. (800) 422-5133 (mail order)

A READER'S DIGEST BOOK

Edited and produced by David & Charles Publishers

First published in Great Britain in 1996
U.S. edition published in 1997

Library of Congress Cataloging in Publication Data

Green, Caroline.
 [Ultimate greetings card book]
 Creative greeting cards : personalized projects for all occasions
 Caroline Green.
 p. cm.
 Originally published under title: Ultimate greetings card book.
 Includes index.
 ISBN 0-89577-983-8
 1. Greeting cards. I. Title.
TT872.G74 1997
745.5941—dc21 97-11849

Printed in Great Britain

Contents

Getting Started

*G*iving a card can bring so much pleasure if you have made it yourself, and yet you don't have to be particularly artistic to create a beautiful and original greeting card. Each project can be a way to develop a new craft skill which may grow into a hobby. You may begin by making a single birthday card for a special friend and then find you are inspired to make all this year's Christmas cards.

All the basic techniques are explained here, so it is advisable to read through this chapter first. You will find advice in the instructions for individual cards.

I hope this book will encourage you to try some new skills and will offer the inspiration to help you remember special days with a sense of achievement.

Basic equipment for homemade card making.

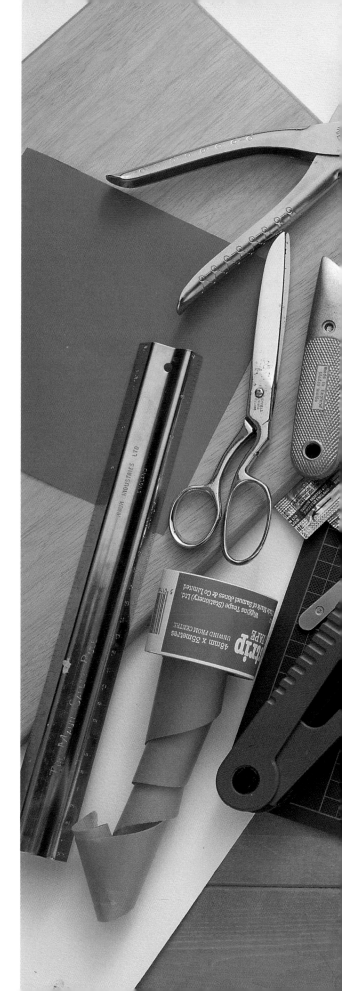

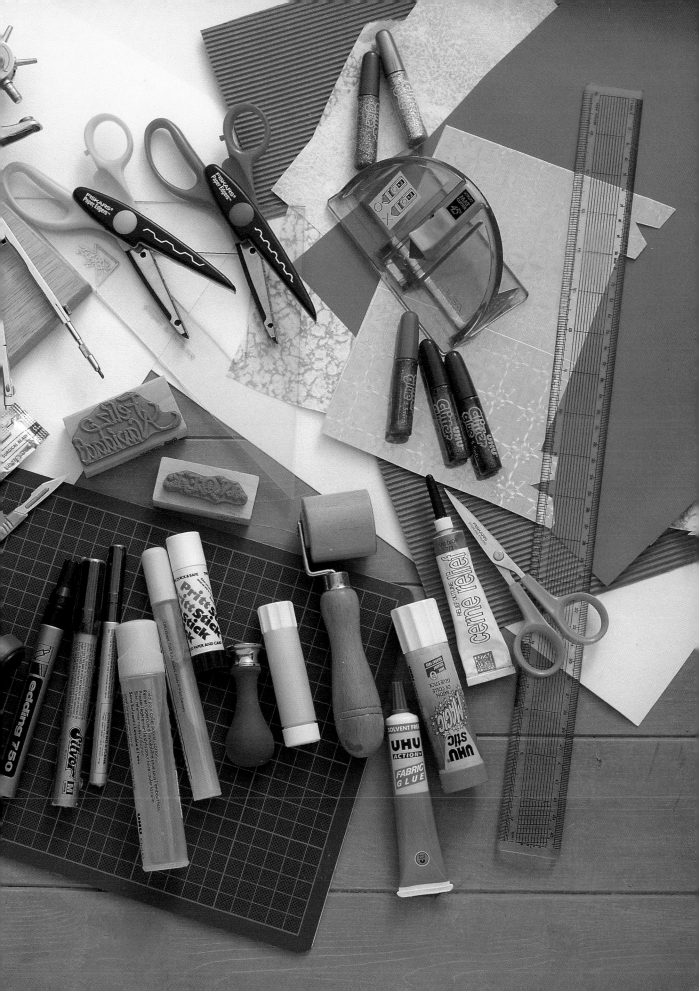

Equipment

All of the equipment shown on pages 6 and 7 is used at some time or another for the projects in this book. The specific materials required for each particular project are listed separately under individual project headings. Some general advice follows for choosing the correct adhesive and paper for the job.

ADHESIVES

White glue for paper and wood. This glue makes a very strong bond when dry, but because it is water based it may make thinner papers buckle or stretch and wrinkle.

Art and craft spray adhesive for all paper and fabric, particularly large areas to be glued flat with no risk of wrinkling. It allows for repositioning in the first few minutes.

Low-temperature glue gun and glue sticks for attaching items such as shells, buttons, or beads.

Rubber cement for gluing and attaching sequins, beads, ribbons, flower stems, etc.

Glue stick for small paper-to-paper applications, sealing envelopes, and quick repairs.

Using Spray Adhesives

Lay the piece to be glued face down inside an empty cardboard grocery carton. Spray gently from side to side to give a fairly light, even coating. Leave for a few moments and then put it in position on your card. If you have not placed the piece correctly, carefully lift it off and reposition within the first few moments. When you are satisfied with it, lay a piece of scrap paper over the top and press it down firmly for a permanent bond.

PAPER AND CARD STOCK

Many different kinds of paper can be used for greeting cards. The most obvious choice is lightweight card stock, available from art supply stores in a wide range of colors and some metallic finishes. You can also use heavy watercolor paper or drawing paper. Wrapping paper is another option, though it will need to be mounted onto card stock with spray adhesive. For a permanent bond, art and craft spray adhesive is ideal; this will glue the pieces together without any risk of buckling or bubbling on the surface. Let the glue dry thoroughly and always use a very sharp blade before you attempt to cut or score the bonded card or you may damage the thinner paper layer.

Cutting Out the Card

Always use a sharp mat knife, a self-healing cutting mat, and a metal ruler. If you don't have a self-healing cutting mat printed with a grid so that you can cut along the lines for accurate edges, a piece of particleboard and a right-angled triangle will suffice. The blade of the craft knife will last longer if used with the mat.

Making Envelopes

The size of your finished card is very important, especially if you want it to fit an existing envelope and put it in the mail. Tiny cards may be lost in the mail if sent inside a tiny envelope, and extra large ones are equally at risk and may get damaged or bent. If you have an existing envelope you may want to make your card fit in it, or find the sizes of easily available readymade ones and make a batch of cards to fit them. This is particularly important when

making Christmas cards or special party invitations.

If the design of the card comes first and it is a single card for a special occasion, you may feel it calls for a special envelope in a color to complement the card, perhaps with a tissue lining to protect a delicate design. You can also incorporate extra stiffening or padding to ensure that the card does not get damaged in transit.

1 Follow the cutting plan (right). The central panel should be slightly larger than your finished card. Carefully lengthen or shorten the flaps so that they fold over and overlap sufficiently in the middle. Make a rough prototype from scrap paper and draw the plan for the finished envelope on tracing paper.

2 Using a good-quality paper, transfer the envelope pattern onto it. Cut around the outline using a mat knife, cutting mat, and metal ruler. Score along the dotted lines on the right side so that the flaps will bend over neatly to form the envelope.

3 To line the envelope, cut out a piece of tissue to the same shape as the envelope, but about ³/8 inch smaller all around. Center this on the reverse of the envelope and glue it in place.

4 Fold in the two side flaps, then glue the lower flap in place to form a pocket for the card. Place the card inside, and then run a line of glue along the edge of the upper flap. Fold this over and press to seal.

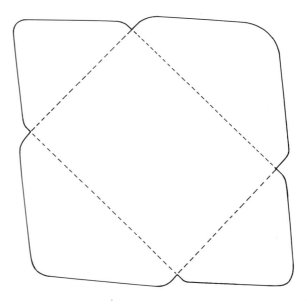

Use this basic plan to make your own rough prototype before cutting out an envelope. Adjust the proportions to match your chosen card.

Making Mounts

Another important matter is to choose the best structure, or mount, for your greeting card. It should complement both the colors and style of the design, and the material you choose to make your mount should be physically strong enough to stand up for display.

There are two main types of mount to consider. The simplest is a plain mount; here the picture, flower, or embroidered design is attached to the front of a folded piece of decorative paper or card stock. The other type is a window mount, usually made of card stock, which has an opening, or "window," cut in the

center. This can be used as is or covered with fabric or paper. The window can be decorated with ruled borders drawn with a silver or gold fiber-tipped marker, or a color chosen to match the design that it frames.

Shaped window mounts also create lovely cards, with the design of the window itself forming part of the main motif.

To make a mount for your card you will need an assortment of materials, including paper or fabric to complement your design; marbled paper or giftwrap; white paper; colored card stock; silver or gold markers; ribbon.

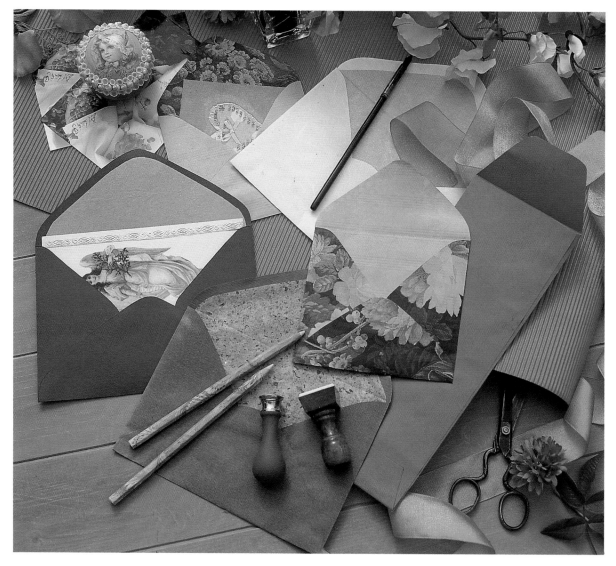

PLAIN MOUNT

Choose decorative or plain paper that will go with your design to form the card itself. Your cut-out design can be glued, sewn, or tied in place in a simple or decorative way. If you have a very small motif, a hand-torn undermount, positioned behind the motif, can emphasize and make the most of it.

1 Decide on the size of your finished card and cut out a piece of thin card stock measuring roughly the height your card will be and twice its width. Lay a metal ruler across the middle of the card on the right (outer) side, and score a

Specially made envelopes will complement your original card designs. You can even use patterned giftwrap if you glue a plain label on the front for the address.

vertical line using the back of a knife blade or a worn out ballpoint pen. This should make a sharp indentation in the surface of the paper.

2 You will find that you can now bend the paper easily. Fold it in half to form the card, then sharpen the fold by rolling it with a wallpaper seam roller or a similar tool.

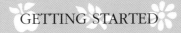

3 Now use the grid lines on your mat, or a right-angle triangle, to mark the top, bottom, and side edges of the folded card so that it is exactly square. Cut through both layers together using a sharp mat knife and a metal ruler so that the back and front match exactly.

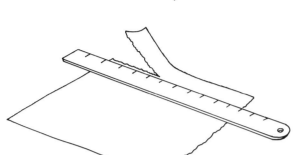

4 For a smaller 'undermount,' a paper background which goes under the main motif (see the flower cutouts on pages 108 and 109), you can add a piece of paper with hand-torn edges. Cut the paper about 1 inch larger than you want the finished piece to be. Place it on a flat surface and lay a metal ruler on top, a little way in from one edge. Hold the ruler down firmly and tear the free edge of the paper along the ruler to leave a deckle-edged effect similar to handmade paper. Turn the paper around and tear the other edges in the same way. Use spray glue to fix it to the front of the card.

5 Try making two- and three-fold cards for different effects (see illustration below).

6 For a more luxurious look, you can make a lining from white paper on which you can stamp or write your message. Cut a piece of white paper slightly smaller than the unfolded card. Fold it in half and glue it lightly to the inside of the card near the fold.

WINDOW MOUNTS

Window mounts are ideal for displaying embroideries and designs that use fabrics. They require a little more care in the cutting, but it is quite easy to achieve professional results. You can buy readymade window-mount cards in many different designs, sizes, and colors, but you will find that making your own is cheaper and offers much more flexibility.

1 Cut the paper roughly to size, making it three times the width of the front of the finished card, and score two folds to make three equal panels. In pencil, mark the area for the window on the center panel. If the window is to be square or rectangular, lay a ruler on one side of the window shape and run the knife along it so that it cuts just outside the line. Repeat this on the other three sides and lift out the center piece. Now try the mount over your design.

2 Mark on any border lines in pencil. Use silver or gold fiber-tipped markers to draw these in varying widths. You can also add strips of marbled paper or giftwrap to further embellish the mount. If so, cut one strip for each side and glue them in place, mitering the corners neatly (see page 12).

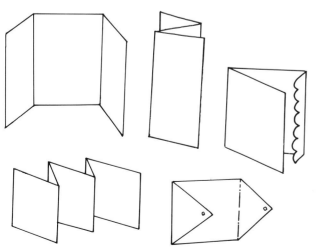

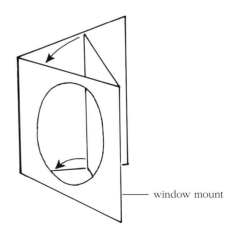

window mount

3 You can also cut out round and oval windows for different projects. Use upturned bowls, cups, or glasses to mark out the shapes accurately. Several small rectangles set together will look like a real window (below), and you can decorate the outside of the card with pretend curtains and the inside of the right-hand flap with a lovely view.

4 To enclose an embroidery or fabric design and make the inside of the card neat, a window mount is ideal. The two folds in the card create three panels. To position your design, open the card and lay it flat, so the inside is upward. Place your design on the center panel, making sure it is correctly positioned. Spray the inside of the left-hand panel with glue and fold it into place behind the embroidery or fabric design.

Borders

Window mounts can be decorated with ruled or mitered borders for a professional finish.

Ruled Borders A frame of hand-ruled lines in gold or silver can give a modern or traditional look to your design.

1 Mark borders around your window or undermount with light pencil lines. Using a ruler, measure the distance around the window or the edge of the undermount.

2 Lay the ruler along one line with the bevel underneath. This ensures that the edge of the ruler is not touching the design.

3 When using a gold or silver marker, shake as directed to distribute the color evenly and then test it on a scrap of paper to produce a smooth, even line. Draw the border line following the edge of the ruler. Let the ink dry before moving the ruler.

4 Turn the card around and draw the border lines on the other sides in the same way.

5 If you are making a double or even a triple border, complete the inside one first, then work outward in the same way for the other lines.

Mitered Borders Decorative strips of paper or fabric make interesting borders and will enhance some of the simpler designs. The corners of the strips should be mitered as described below.

1 To make the decorative border, cut four strips of paper or fabric a suitable width to go around your design or window. Cut the pieces longer than the sides of the window to allow for making mitered corners.

2 Spray the reverse side of the strips with adhesive and then place them lightly around the window, making sure the inner edge of each strip is the same distance from the edge of the window. The adhesive will allow you to reposition the strips for accuracy.

3 Lay a ruler across each corner in turn, lining up the edge of it with the inner and outer points where the strips overlap. Use a mat knife to carefully cut the miters at each corner, going through both thicknesses of paper or fabric at the same time to make a perfect join. Remove the excess pieces of paper and press the strips down firmly to bond.

Personalized Messages

Many people can make a delightful design for a card but tend to panic at the thought of doing any lettering. If you prefer, you can write your personal message inside the card in your own handwriting, but for a professional look you should choose another method for the lettering on the front of the card.

CALLIGRAPHY

You can use decorative italic lettering in wonderful colors and arrangements for both the front and the inside of your card. There are many inexpensive calligraphy pens on the market, both fountain and felt-tipped, with instruction books that should help you to produce most acceptable writing.

STAMPS

There are many rubber stamps marketed for home craft use, and some of these have messages as part of the design. You can use these to print the wording inside your greeting cards, or make some of the more decorative versions into the main design on the front of the card. The inks used with these stamps vary from quick-drying colored inks to metallic-embossed inks for a very professional and expensive-looking finish.

PHOTOCOPYING

Photocopy lettering from newspapers, magazines, and old greeting cards and then cut them out or trace them to use on your cards. Enlarged numbers are particularly useful for birthdays and anniversaries, while letters are good for names and linked initials on wedding or engagement cards.

COMPUTER PRINTING

If you own a computer and printer you will be able to print virtually any message. Work on white paper and make this into a card lining to glue inside your finished card. If desired, you could cut out larger lettering and glue other motifs around the words to make a very attractive and personal design.

STENCIL LETTERING

Inexpensive plastic stencils have been around for many years, and they can be used very easily for making cards. The secret of a good finish is to draw a faint pencil line before you begin and then align the base of all the letters along this. It is also a good idea to do a rough version on scrap paper to adjust spacing and to determine the best position for each word or number. Fine fiber-tipped markers and colored pencils are easiest to use, or you could draw the outlines with a technical pen and color in the center of each letter with watercolor or poster paints.

You could also make your own stencils. Cut out your own letters or words from an acetate sheet and fill in with paint using a brush or sponge and acrylic paints.

DRY TRANSFER LETTERING

There are several brands of dry transfer lettering available from art supply stores. They come in sheets of individual letters which you arrange along a guideline to form the words. The letters are made from very thin self-adhesive plastic strips that you transfer onto paper by burnishing with a ballpoint pen. The lettering is quite expensive to buy, but there is a very large range of sizes and typefaces so you can achieve exactly the right finish. It would be ideal as a way of making a master copy for an invitation, which you could photocopy as many times as necessary and then mount and hand color. It is also perfect for making the number cards described on page 18.

If you haven't got time to create your wording from single letters, you can also buy sheets of ready spaced messages, such as Happy Birthday, Best Wishes, and Merry Christmas, which are much easier to use since you do not need to arrange the letters individually.

Displaying Cards

Displaying cards in large quantities, especially at Christmastime, can be an art in itself. Here are several ideas for useful and decorative displays.

POSTERBOARD HOLDER

This is made from two sheets of medium-thick posterboard held together in the center and hung on the wall. The greeting cards are then inserted between the layers of posterboard at various angles. The holder can be made in a long rectangle to hold the cards in a vertical display, or you could make it round or star-shaped to display the cards in a circle.

To make a posterboard holder you will need: at least 5 by 20 inches of medium-thick posterboard; tartan-patterned board; gold or silver card stock; white glue; plate hanger and ribbon for decoration.

The posterboard holder (left), simple stand (center), and ribbon-and-bow hanger (right) show how you can display your cards in a variety of ways.

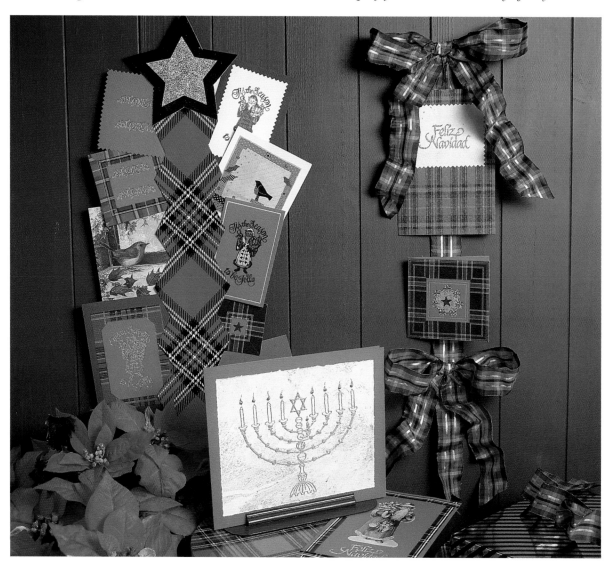

1 For the front of the card holder cut out two stars from silver or gold card stock and a zigzag-edged rectangle of tartan-patterned posterboard. (You may need to mount tartan-patterned paper onto some posterboard to achieve the right thickness.) Attach the stars to the tartan shape.

2 From the posterboard, cut the back a little larger than the front piece. Keep to a simple rectangular shape, as this will not be seen when the cards are in position.

3 Spread white glue down the center of the backing piece and center the front piece over it. Weight it down with books and let the glue dry.

4 Turn the holder over and glue the plate hanger to the back so that the ring is at the top for hanging. You can also decorate the front of the holder with ribbon or seasonal decorations.

5 To display the cards, insert them between the layers of board all around the holder. You can do this for either a random arrangement or an aligned one, depending on your taste and the cards you have.

RIBBON-AND-BOW HANGER

For a pretty wall-mounted display, ribbon makes an ideal surface on which to glue or staple cards. To make the hanger you will need: wide satin or wire-edged ribbon (at least 2 yards); white glue or a staple gun and adhesive pads or a hook for hanging.

1 Cut a piece of ribbon at least 1 yard long. Tie some of the same or contrasting ribbon into a large bow and glue this to the top of the ribbon so that the tails of the bow hang down on either side.

2 Staple or glue the greeting cards to the length of ribbon, starting just under the bow and working your way down to the end. Leave a small gap between each card so that you can see the flat ribbon passing behind them.

3 To finish, leave about 2 inches of ribbon free at the end and make another bow as for the top. Glue this bow in place and trim the tails to complete.

4 Hang the card display on the wall using a picture hook or adhesive pads.

SIMPLE STAND

This tiny stand is very useful if you want to display a single card for some time. The lower edge of the greeting card is held between two pieces of wooden beading or molding mounted onto a piece of posterboard. You can paint the stand for a more decorative effect. To make a simple stand you will need: wooden molding or quarter-round beading; small hacksaw; fine sandpaper; wood glue; a piece of thick posterboard; acrylic paint; watercolor brushes.

1 Using the saw, cut two pieces of molding about 4 inches long. Sand the cut edges until smooth, center the molding on the piece of posterboard, and glue them in place, leaving a small gap between them to hold the card.

2 Let the glue dry, then trim the card base to the desired shape and size to support the stand when the greeting card is in position. The larger the greeting card, the larger the base of the stand will need to be.

3 Paint the stand in the desired color and let it dry before using.

CHAPTER 2

Special Occasions

*I*t is not always easy to find exactly
the right card for a particular friend
or family member, so what could be
more personal than a card made by
hand for a special occasion such as a
birthday? Not only will these cards be
treasured but they are fun to create and
certainly are a welcome change from
run-of-the-mill store-bought cards.

*Choose the perfect card for the perfect occasion.
Any of these designs can be adapted to make
greeting cards for friends or family of all ages.
All the cards shown here are described in the
following chapter, for instructions see specific
projects: (clockwise from top left) sealing wax
motif window card (page 24), cancer zodiac
card (page 25), a window card with a sequin
butterfly as the motif (page 24), a chain of teddy
bears (page 23), tree of life card (page 22), the
sun card (page 20), and another version of the
window card (page 24) featuring an initial.*

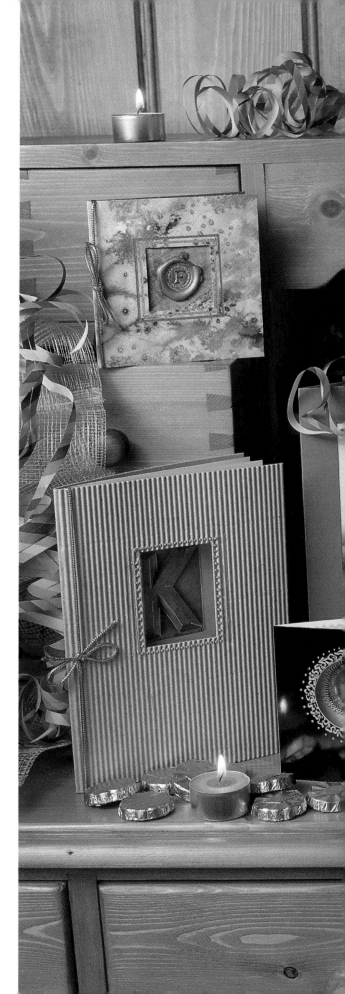

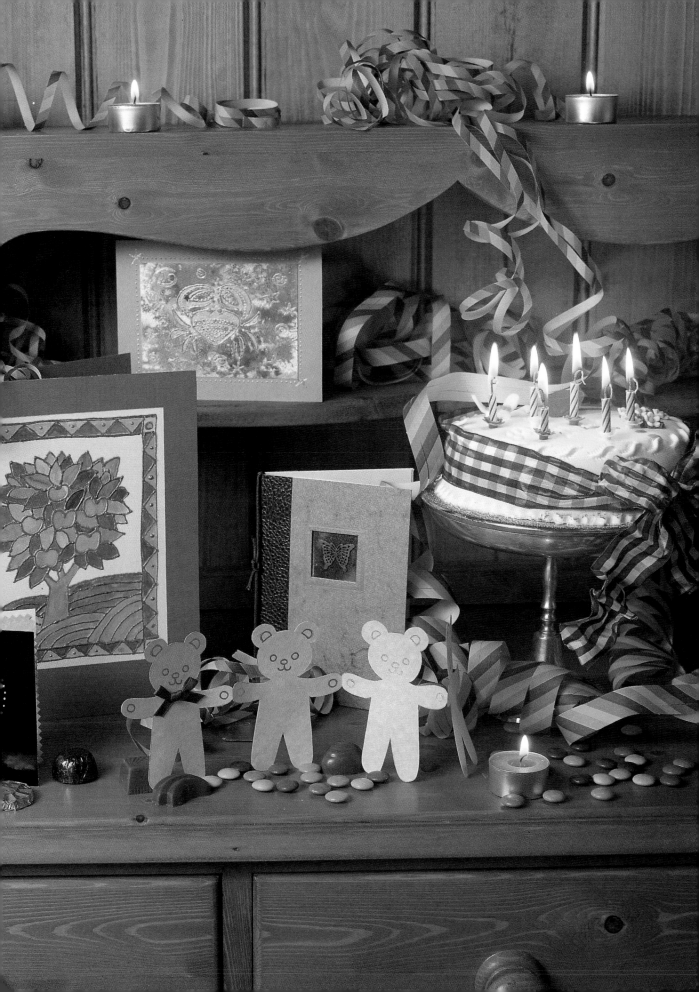

CARDS TO MARK MILESTONES

Choose one of these designs and then add the numbers to correspond to the recipient's birthday. If you do not feel confident to draw the number you require, look through magazines and books to find the style you want, and trace the number from there.

MATERIALS YOU CAN USE
Gold paper or card stock
Folded cards (see page 11) in solid-colored, patterned, or metallic card stock
Scraps of fancy paper in subtle tones
Gold marker
Gold and black relief outliners
Relief paints in pearl colors
Tassel
Dry transfer lettering

1 Draw or trace the appropriate numbers and transfer the shape to gold paper or card stock. Then cut out carefully, using a mat knife and cutting mat.

2 Spray the reverse side of the numbers with glue and place on your prepared card. Add cut-out motifs and decorations made with the gold outliner and marker.

For the card with the three-dimensional number (facing page, center), enlarge the appropriate number from a newspaper or magazine and then add dimensions. To do this, draw angled lines from the points of the figure as shown. Then join these lines following the shape of the edge of the number.

Transfer this design on to the front of your folded card and then draw the outlines with a black outliner. Make random patterns in black in the shaded areas and then decorate the main area of the figure with the other pearly colors of relief paints, filling it with pattern.

For the key card to honor a graduate, for example, trace and cut out the key shape using gold card stock. You can add the numbers into the top of the key, as here, if you wish.

Thread a readymade tassel into the top of the key and then glue the key at an angle to a plain card mount, in the color of your choice.

Opposite
Make a card to mark any mile stone in someone's life—an important birthday, an anniversary or even to celebrate moving to a new home. Simply choose the number to reflect the occasion.

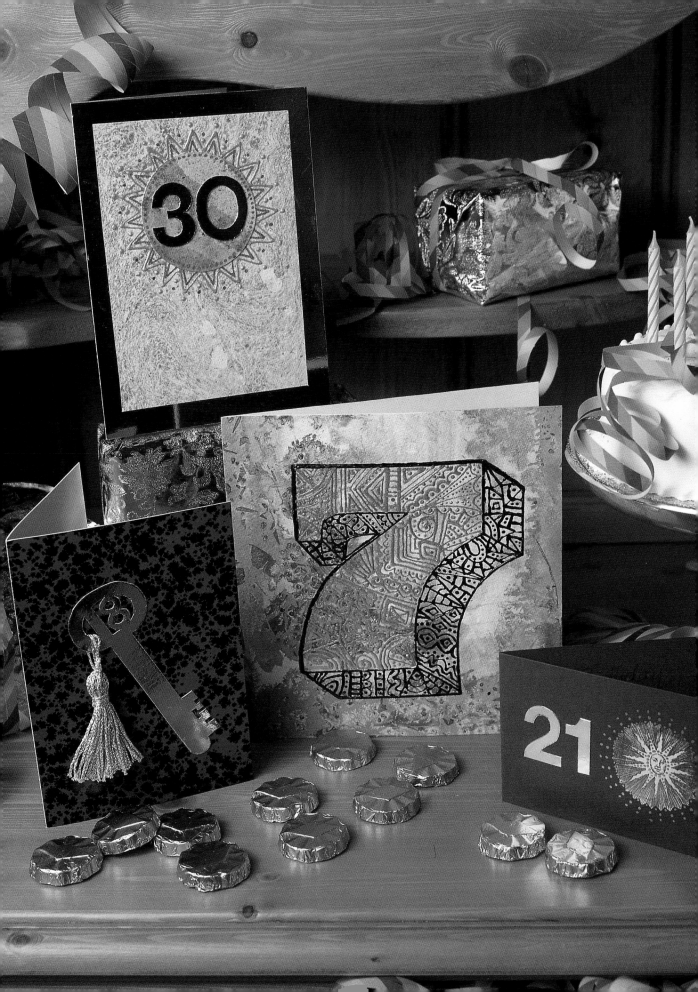

FOR FAMILY AND FRIENDS

To honor your mom or dad, or to give a friend a handmade card on his or her birthday, you can make a card just for the occasion. You can be as artistic as you like. The designs in this section will inspire you to try your hand at something totally new.

Cutout Cards

These cards leave you in no doubt as to whom they are for. The lettering is simple and joined into one block to make a stylish statement.

MATERIALS YOU CAN USE
Card stocks in
various metallic finishes

1 Fold the paper and cut it roughly to size. Select lettering from newspapers, magazines, or old greeting cards and reduce or enlarge to the required size. Cut the letters out, arrange into words, and trace them onto the front of the card ready for cutting out (the fold should line up with the left-hand edge or the top of the row of letters). Draw over the outline of the letters with a hard pencil to leave an indented line in the surface of the foil to follow when cutting.

2 Using a sharp mat knife and cutting mat, cut through both layers of paper at once. Cut out all the internal holes first while the card is at its strongest. Use a metal ruler as a guide when cutting the straight lines. Make sure that the letters are connected as they are cut out; if one is not joined to its neighbor, it will fall apart when cut.

3 Carefully cut out all the various notches and shapes along the edge to complete the card. Write the message inside, following the shapes of the cutout letters.

Sun Card

Bring a little sunshine into the life of someone special. This card can be seen in the photograph on page 16.

MATERIALS YOU CAN USE
Picture of sun cut from a magazine or giftwrap
Shiny black plain card mount
Gold relief outliner
Colored folded paper for lining

1 Cut out a sun motif, then cut a round window in the plain card mount. Make sure the window is slightly larger than the sun motif.

2 Glue the sun to the lining sheet to fit behind the window and decorate around the edge with tiny dots made with the gold outliner. Let dry. Using the gold outliner, decorate around the edge of the window with squiggly lines and dots to look like the sun's rays. When all the gold is dry, glue the lining inside the card to complete.

A steady hand and a sharp knife are vital to your success when making these sparkling cut-out cards.

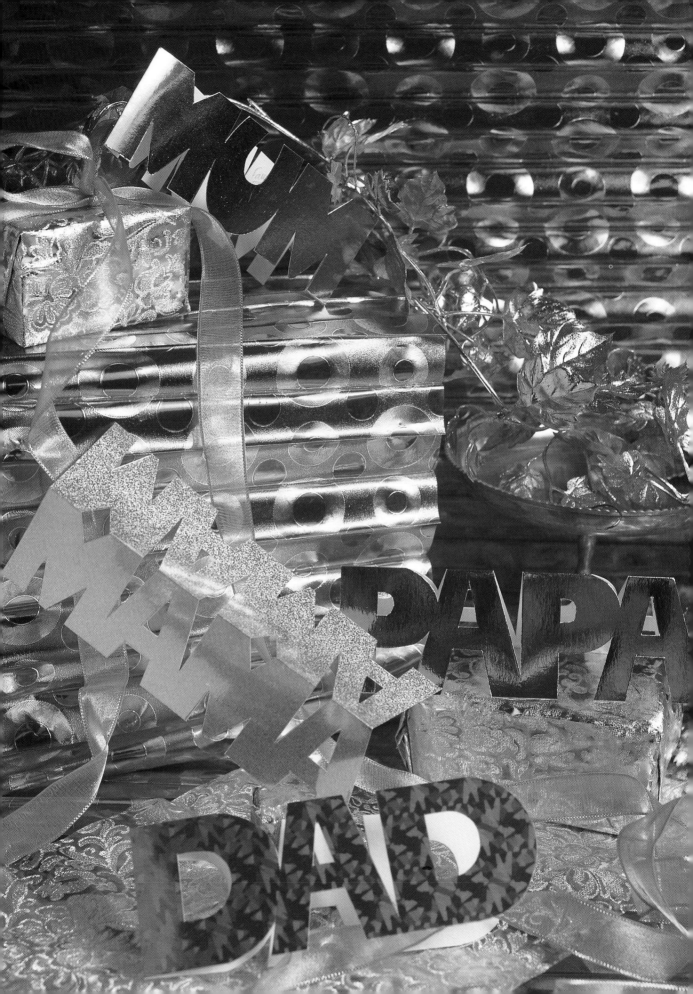

Tree of Life

This painted silk tree of life design would make a perfect card for a special birthday, such as an eighteenth or twenty-first, or wedding anniversary. The tree is a wonderful symbol of life, ideal for marking such an occasion.

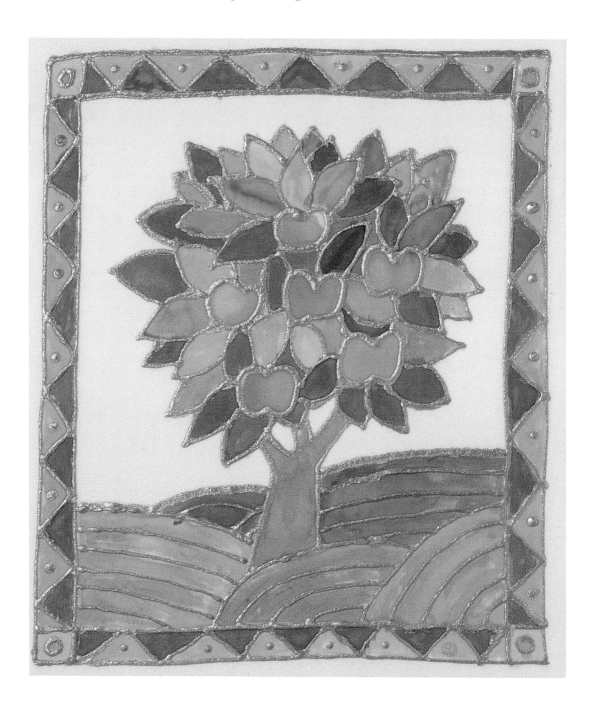

Fine white silk (about 9 inches square)
Silk paints and thinner in red, yellow, and blue
Relief paints in pearly blue and gold
Watercolor brushes
Watercolor paint palette
Fine black waterproof marker
Adjustable frame for stretching the silk
Card stock to suit

1 Using the black marker, trace the design directly from the card opposite; this is exactly the right size for the finished card. Follow the silk painting instructions on pages 98–100.

2 Outline the border, leaves, and foreground using the blue relief paint, and the tree trunk and fruit with the gold. Let set for an hour or two.

3 Mix the colors in the palette and paint in the design. Let it dry, then fix the silk paints by ironing on the reverse side, following the manufacturer's instructions.

4 Tape the finished silk painting inside a window mount with a rectangular window cut in the center section. Fold over and glue the left-hand panel to neaten the inside of the card.

A Chain of Teddy Bears

The teddy bears pictured on page 17 are ideal for younger members of the family. They can be used individually as a fun card or made together in a row to form a decoration for a child's room. You could make the card so that there is a teddy bear to celebrate each year.

MATERIALS YOU CAN USE
Silver marker
Buff-colored card stock
Scrap of narrow ribbon

1 Cut a piece of buff-colored card stock. Trace the teddy bear shape shown on the right. Tape the tracing to the top of the card so that the paws overlap the folded edges slightly. Fold it vertically accordion-style to make as many teddy bears as you need. If you want to make more than about five teddy bears it is best to do them in two lots to avoid the risk of the paper layers slipping as you cut.

2 Using a sharp knife, cut out around the edge of the teddy, making sure that the paws stay joined at the folds.

3 Open the card and draw the features on each bear with the silver marker, then write your message. Add a tiny bow to the front teddy to dress him up.

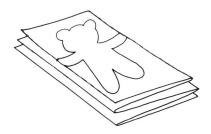

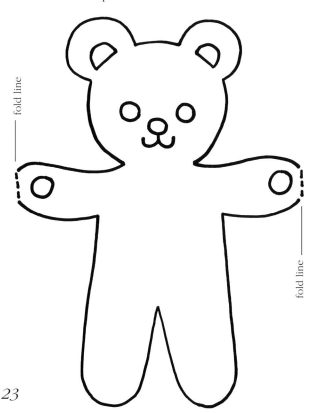

fold line

fold line

Window Cards

The central motif that you choose to show in these windows (pictured on pages 16–17) makes them a reminder of a special day.

MATERIALS YOU CAN USE
Assorted colored card stock or
corrugated cardboard
Decorative motif cut from magazines or giftwrap
Lining paper
Colored cord
Gold relief outliner
Gold marker
Gold sealing wax and seal with appropriate letter
Aluminum foil

1 Decide on the size of the window in your plain mount and fold a piece of card stock or corrugated cardboard to display the motif attractively. Cut the window and decorate around the edge with the outliner or marker.

2 Make a lining for the card to fit just inside the the outer edge. Tie it in place using a decorative cord or ribbon and trace the shape of the window onto the lining with a faint pencil line.

3 Spray the back of the motif or letter with adhesive and glue it in place on the lining so that it is perfectly positioned behind the window.

For the sealing wax motif, make several trial stamps to get a really good one. Working on a piece of foil, carefully light the wax and allow a small pool to form on the foil. Dampen the seal and press it into the center of the melted wax. Let the sealing wax stamps cool until they are hard, then peel off the best one. Glue it to the lining paper to show through the window of your card.

Using a Fictional Character

Children love cards decorated with characters from their favorite movie and television show. Cut motifs out from magazine articles. To set the scene for your design you can easily make a simple background for the figures. You can make a collage using other images from magazines or colored paper, or draw your own scenery.

MATERIALS YOU CAN USE
Plain white card mount
Colored background paper
Figures to cut out

1 Using small sharp scissors, cut out the characters. If they are on thick cardboard, thin by carefully tearing off some of the card from the back of the print.

2 Make a rough sketch of your final design on a piece of scrap paper to gauge the size card you will need. Cut the card to the correct size and fold it in half.

3 Cover the front of the card with the background paper or draw in some scenery to make a suitable background. Cut pieces of paper to match these scenery shapes, spray the backs with adhesive, and lay them in position on the card. Trim the edges even with the card.

4 Now spray the back of the cutout characters with adhesive, one by one, and lay them on the background. Lay a sheet of clean, spare paper over the top and smooth the pieces flat to make sure they are glued in place properly.

ZODIAC CARDS

The twelve signs of the zodiac are designs suitable for birthday greetings (see pages 26–27).
Use an outline drawing of the sign on a richly painted background. You can then
embellish this with the symbol and write details inside of birthstones and
colors associated with each sign.

MATERIALS YOU CAN USE
Watercolor paper
Colored waterproof inks
Watercolor brushes
Gold marker
Gold relief outliner
Plastic wrap and sea salt
Gummed paper tape
Drawing board
Colored card stock and white lining paper

1 Paint the watercolor-paper backgrounds with colored waterproof inks following the instructions on pages 94–95. Use suitable colors to go with each star sign, and think of the element (earth, air, fire, or water) represented by each. Splash the painted surface with tiny spots of gold and silver ink.

2 Trace a motif from pages 28–29 and transfer this to the painted background paper.

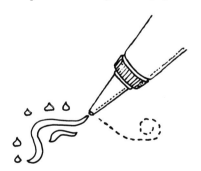

3 Using the gold relief outliner, follow the traced design of the star sign, adding gold dots and lines to create texture and pattern within the shape. Hold the point upright and squeeze very gently to expel a thin, even line of color. (If you make a mistake you can wipe it away quickly with a dry tissue without spoiling your artwork.)

4 When the gold outliner is dry, shade in some areas of your design with a gold marker to help the design stand out from the background colors.

5 Cut out the piece of decorated watercolor paper with pinked or straight edges and then make a folded card, choosing a color to go with the star sign background. Spray the reverse side of the painted paper with adhesive, let it set momentarily, and center it on the front of the folded card.

6 For decoration use the gold relief outliner to make a decorative border around the edges of the watercolor paper as shown.

7 Add a white lining to the cards, and, if you wish, write in details of the appropriate birthstone, color, and element using a gold marker.

Following pages: *Choose the appropriate star sign from this collection. The signs shown are: sagittarius and pisces bookmarks (top left), gemini, taurus, libra and virgo cards (top row, left to right); capricorn, aquarius, leo and cancer cards (center row, left to right); scorpio card (bottom left) and aries card (bottom right).*

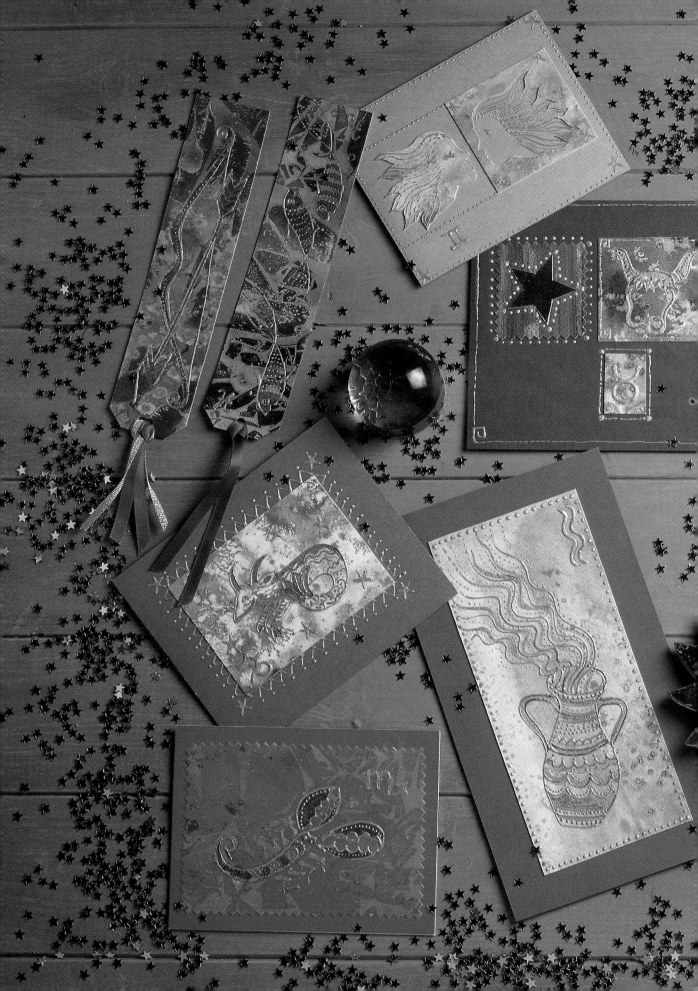

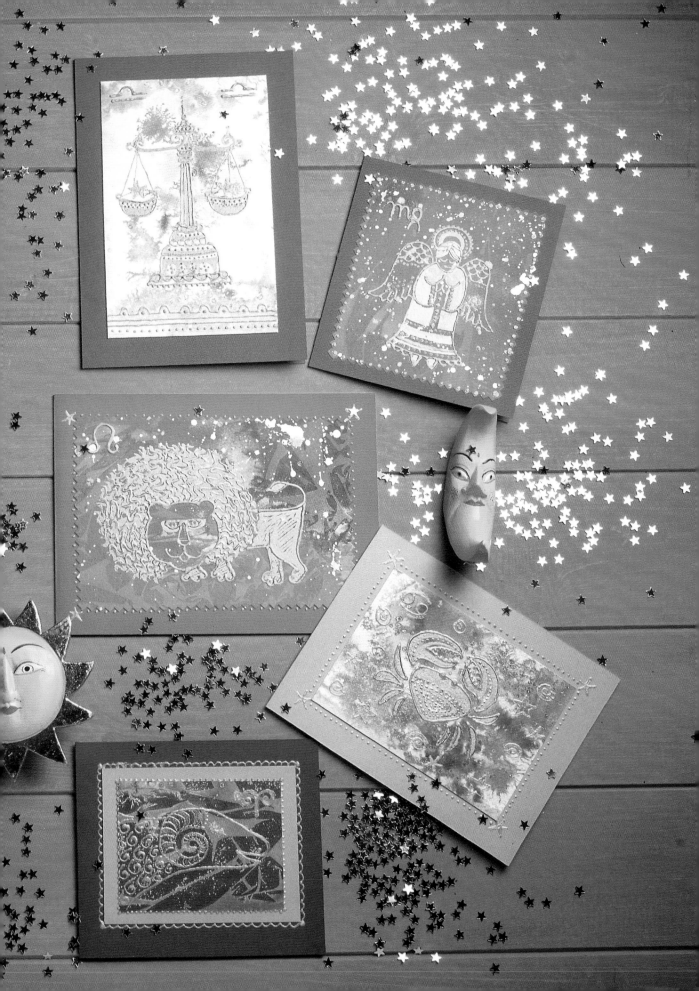

AQUARIUS (January 21–February 19)
element **air**
color **turquoise**

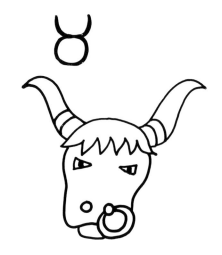

TAURUS (April 21–May 22)
element **earth**
color **pink**

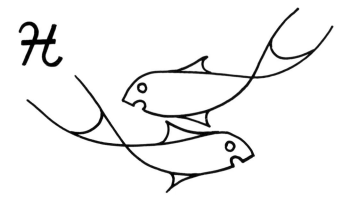

PISCES (February 20–March 20)
element **water**
color **sea green**

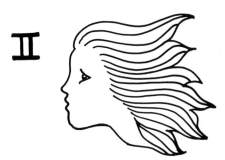

GEMINI (May 23–June 21)
element **air**
color **yellow**

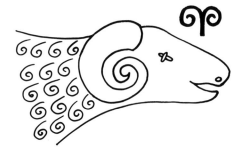

ARIES (March 21–April 20)
element **fire**
color **red**

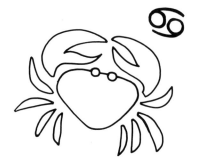

CANCER (June 22–July 22)
element **water**
color **silver gray**

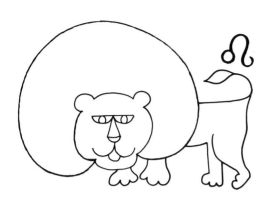

LEO (July 23–August 22)
element **fire**
color **orange**

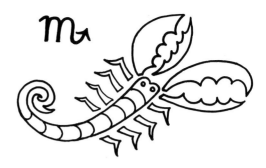

SCORPIO (October 23–November 21)
element **water**
color **dark red**

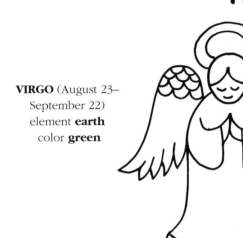

VIRGO (August 23–
September 22)
element **earth**
color **green**

SAGITTARIUS
(November 22–December 22)
element **fire**
color **purple**

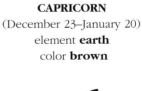

CAPRICORN
(December 23–January 20)
element **earth**
color **brown**

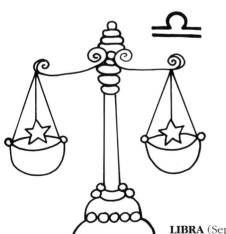

LIBRA (September 23–October 22)
element **air**
color **pale blue**

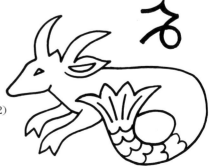

Celebration Themes

*H*ere is a host of ideas for cele-
bration cards that will delight
anyone lucky enough to receive one. You
can celebrate Christmas, Thanksgiving,
New Year, Valentine's Day, St. Patrick's
Day, and many more in your own
unique style.

*Cards can be made for any of the many festivals
and celebrations throughout the world. Shown
here are, clockwise from top right, a card for the
Jewish New Year (see page 39), one for the
Chinese New Year (see page 40), the Star of Gold
card (see page 32), a dried flower collage card to
celebrate the harvest (see page 106), a stained-
glass card for Easter (see page 41), a St. Patrick's
Day shamrock card (see page 46), Hark! The
Herald Angels card (see page 34) for Christmas,
a Christmas star stained-glass card (see page 41)
next to a Painted Silk Christmas Star card (see
page 34) with another shamrock card between
them (see page 46), a card for the Hindu New
Year (see page 37) below a Universal New Year
card (see page 39), and finally, another
Christmas Hark! The Herald Angels card (see
page 34).*

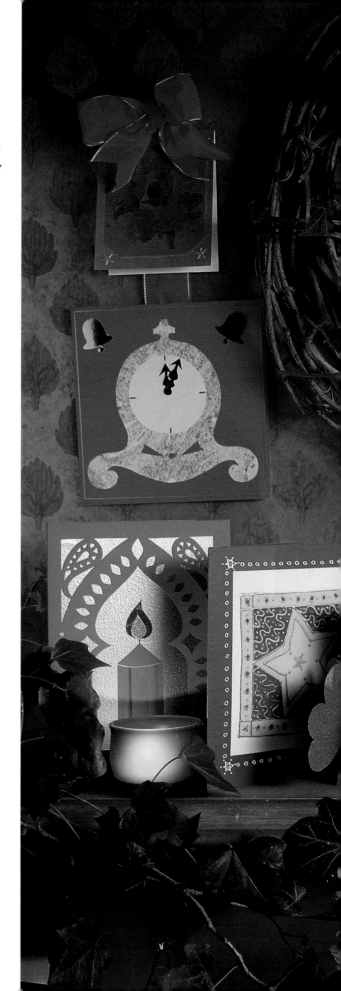

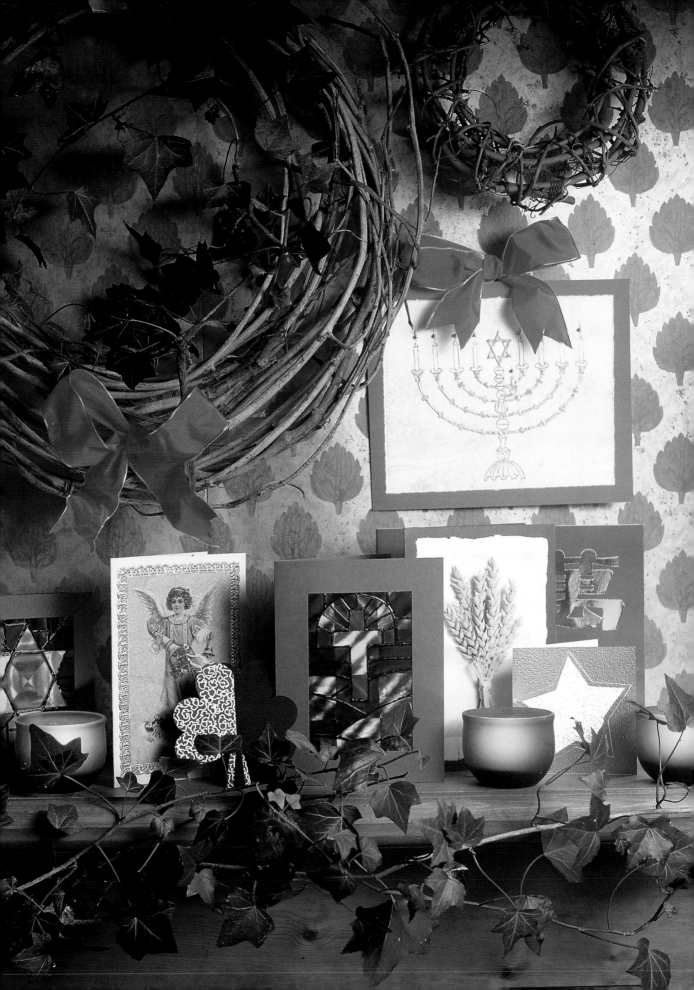

CHRISTMAS

Making your own Christmas cards is great fun, less expensive, and far more personal than sending out the readymade type. Stenciling and stamping are the ideal techniques for adding the wording inside a quantity of Christmas cards and will give very professional results.

Fabric Tree Card

This cutout collage shown opposite can be made with any leftover fabric scraps that you already have. The silver card stock creates a stunning effect against the fabric.

MATERIALS YOU CAN USE
Scraps of brightly colored fabric
Silver card stock
Colored paper

1 Trace the half template of the Christmas tree on page 127 onto folded tracing paper, placing the fold along the dotted line. Turn the paper over and trace the other half to make the complete shape. Then draw in a star, pot, and ornaments by hand.

2 Transfer this to the reverse side of the silver card stock, positioning it so that it will be on the front of the card when the mount is folded.

3 To form the card, use a mat knife and cutting mat, cut out the Christmas tree pot and star. Score a vertical line 3/8 inch away from the left-hand edge of the tree on the silver side of the card stock. Fold in half along the scored line and trim the other three edges.

4 Cut a piece of colored paper the same size as the front of the card. Slip this inside and draw the position of the tree, star, ornaments, and pot in pencil. Cut out scraps of various fabrics, slightly larger than these shapes and look at them through the front of the cutout card. When you are happy with the arrangement, glue them in place to the colored paper.

5 Open the greeting card and spread glue over the inside of the front flap. Press the colored paper in place so that you can see the fabric correctly positioned through the holes.

Star of Gold

A simple star (page 35) can look both rich and festive when you use different textures of gold.

MATERIALS YOU CAN USE
Gold fabric or shiny gold card stock
Textured gold card stock
Gold relief outliner

1 Use the star template on page 126. Trace the shape and cut it out from a piece of gold fabric or shiny gold card stock to make the central motif.

2 Make a small square plain mount from the gold-textured card stock.

3 Use spray adhesive to glue the star to the center of the card mount.

4 Finally, using the gold relief outliner, draw a border just outside the edge of the star, following the shape carefully.

The cutout technique pictured below can be used with other shapes too. A simple star cutout of dark paper with bright scraps of satin would look very dramatic. Holly leaves and berries would also work well, perhaps with patterned paper and solid-colored fabrics.

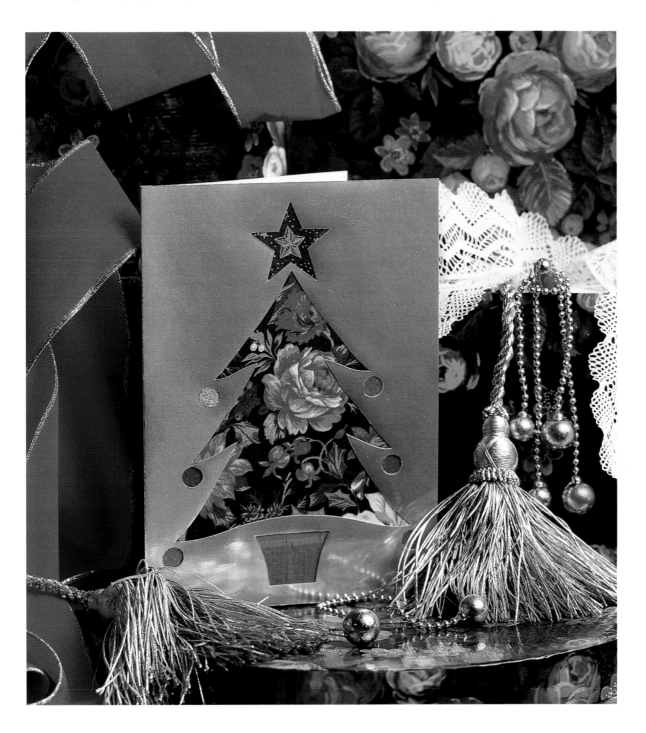

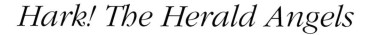
Hark! The Herald Angels

You can make many cards like those shown opposite, from a single sheet of Christmas giftwrap. Tear or carefully cut around the motifs and mount on card stock, adding gold lace borders or tiny gold relief drawn stars at the corners.

MATERIALS YOU CAN USE
Giftwrap with Christmas motifs
Card stock in silver or blue
Gold paper lace edging
Gold relief outliner

1 Using a small pair of scissors, carefully cut out your chosen motif from the giftwrap. Cut a rectangle from card stock to fit your motif, and fold.

2 Spray the back of the motif with glue and position it on the front of the folded card.

For a gold paper lace edging, cut and gluue pieces to fit around the motif. Overlap at the corners and then cut through to make a miter (see page 12).

For the hand-torn edged card, cut out the motif leaving more background than needed, then use a metal ruler to tear the edges into a square around it (see page 11). Tear off the corners in the same way, and then use spray adhesive to glue it to the front of the folded card. Decorate the corners of the finished card with little stars drawn with the gold outliner.

Painted Silk Christmas Star

A gorgeous Christmas design in an unusual blue and yellow color scheme (see photographs on pages 30 and 36). For a more detailed explanation of the silk painting technique, see page 98.

MATERIALS YOU CAN USE
Fine black and silver waterproof markers
Adjustable frame for stretching the silk
Fine white silk (about 7 inches square)
Silk paints in red, yellow, and blue
Thinner for silk paints
Relief paint in silver and gold
Watercolor paint palette and brushes
Card stock for window mount

1 Using the black marker trace the design carefully from the photograph on page 36. Cut out the silk slightly larger than the outer edge of the design. Using the frame, stretch the silk. Tape the design underneath the silk, so that you can see it clearly.

2 Using the silver relief paint, draw the main parts of the design. Then draw the inner stars and the dots with the gold relief paint. Let it set for an hour or two.

3 Mix the silk paint colors in the palette and paint in the design. To make a slightly warmer yellow, add a drop of red to the yellow silk paint.

4 Let the finished design dry, then fix the silk paints by ironing on the reverse side of the fabric, following the manufacturer's instructions.

5 Tape the finished silk painting inside a window mount with a rectangular window cut in the center section. Fold over and glue the left

Opposite *This luxurious selection of Christmas cards features three Hark! The Herald Angels cards and the Star of Gold (page 32).*

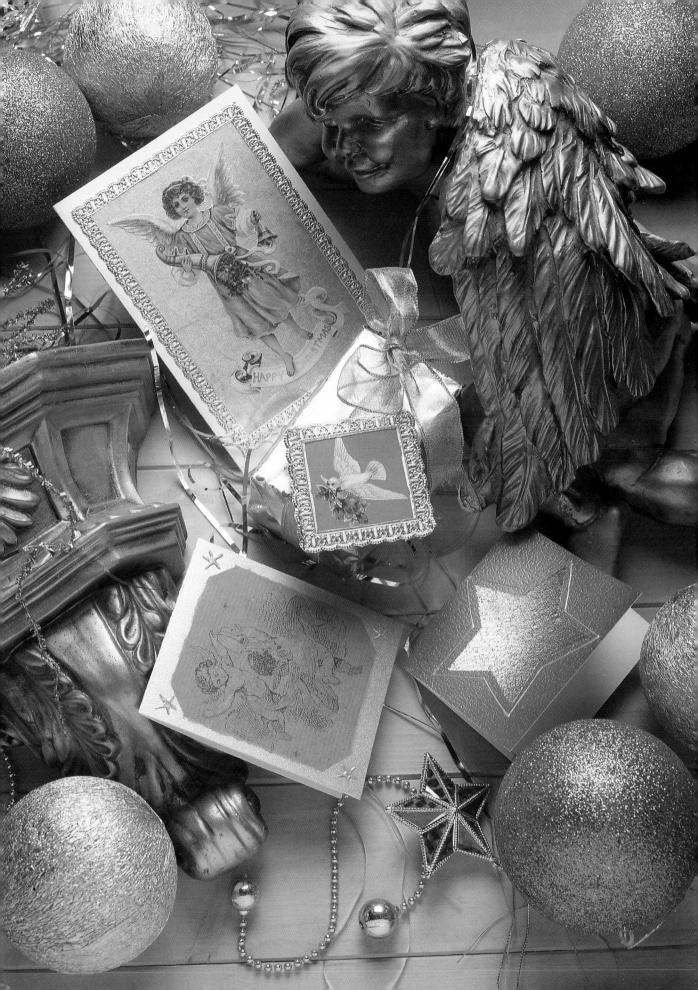

section to neaten the inside of the card. Draw stars and circles as a border around the edge of the window using a silver marker.

Part of the charm of this painted silk Christmas star lies in its jaunty off-center positioning.

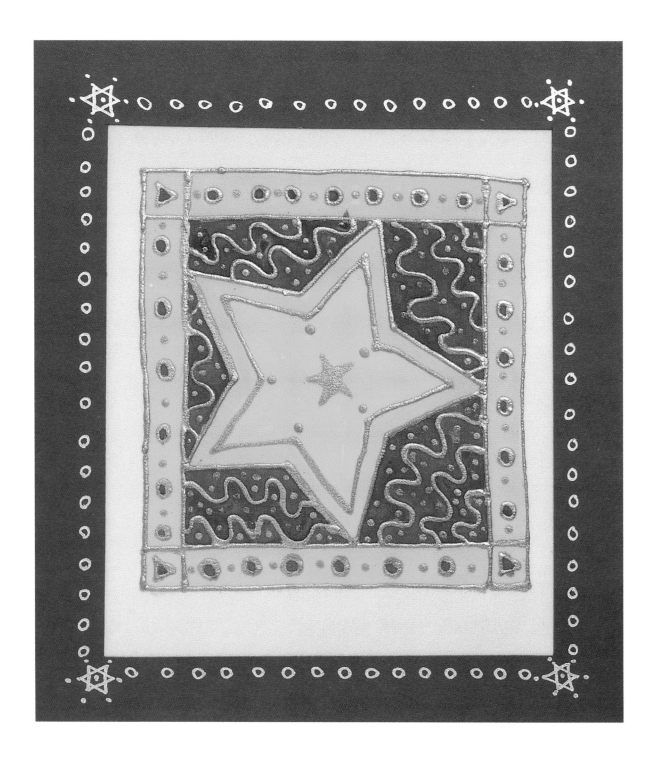

NEW YEAR'S

There are many New Year's festivals and celebrations around the world. If you have friends who celebrate a different New Year's from your own, why not find out a little more about it and choose some of the special motifs or designs to make a greeting card like those shown overleaf especially for them.

Divali, Hindu New Year

Divali is the Hindu festival of light, which marks the start of the new year. It is a movable feast which is celebrated at the end of October or the beginning of November. See photo on page 38.

MATERIALS YOU CAN USE
Red card stock
Gold textured paper
Scraps of colored paper for the candle and flame

1 Using the red card stock, prepare a plain mount measuring 5³/₄ x 8 inches by following the instructions given on page 10.

2 Trace the pattern at right, reversing the tracing paper (as described on page 32) for the other half, and transfer this to the inside of the front flap of the card mount. Using a mat knife and cutting mat, cut out the shaded areas.

3 Place the gold paper behind the cutout area and trim to size around the edge. Spray the inside of the front flap with glue and then mount the gold paper in place to show through the cutout pattern.

4 Cut out the candle and flame from pieces of colored paper, and use the spray adhesive to mount the shapes onto the gold paper inside the arch shape. Choose colors appropriate to the festival of light; in the example pictured on page 38 the candle flame has been cut from small scraps of shiny hologram paper, which gives it a shimmering quality.

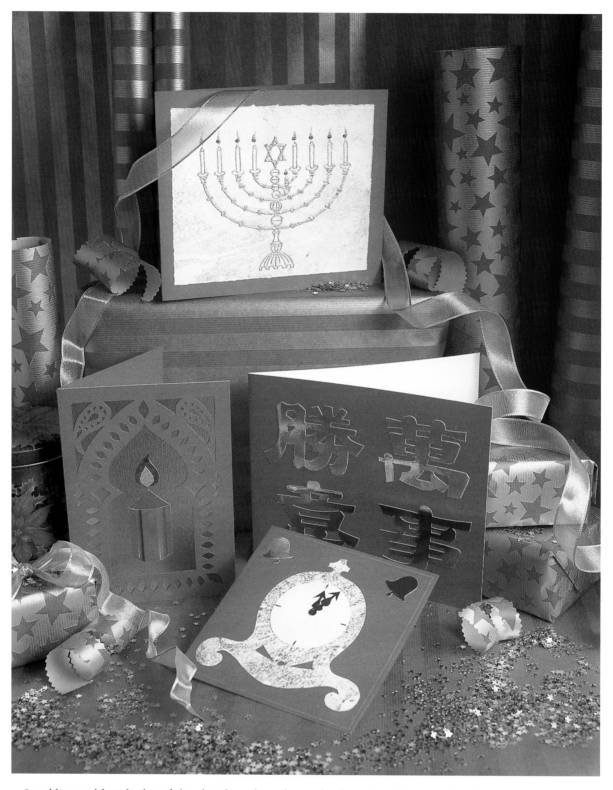

Sparkling gold with cheerful red is the color scheme for these New Year's celebration cards, bringing good luck wishes for the future.

Universal New Year

Ring in the New Year in any language with this elegant clock, set at just after midnight.

MATERIALS YOU CAN USE
Plain red card mount at least 7 inches square
Gold marbled paper
Gold card stock and scraps of white card stock

1 Trace the templates for the hands, bells, and clock, turning the tracing paper over to draw the other half of the clock (see page 32). Using the photograph opposite as a guide, transfer the traced shapes to the appropriate-colored paper and card stock. You will need two bells. Cut along the outlines.

2 Spray the backs of these pieces with glue. Mount the clock, centered, onto the front of the red card. Put on the face, adding four gold marks as shown and setting the hands just after midnight. Place the bells in the top corners.

Rosh Hashanah, Jewish New Year

This card could also be used to celebrate Hanukkah, the Jewish festival of light.

MATERIALS YOU CAN USE
Tiny gold beads
Red card mount at least 7 inches square
Gold marbled paper
Gold relief outliner

1 Fold a piece of tracing paper in half and place the fold on the dotted line of the candelabra template on the next page. Trace the pattern, then turn the paper over and trace the other half to make the complete shape. Note that the tiny candle in the center should appear on only one half of the design. Transfer the candelabra outline onto the gold marbled paper.

2 Use the gold outliner to draw over the traced lines, filling in some areas as shown in the photograph on page 38.

3 Draw the flames of the candles last, and while the outliner is still wet, press a tiny gold bead into each flame to give it a sparkle of light. Let dry, then trim the paper with the hand-torn method described on page 11 and glue it to the front of the folded red card.

Use the template on the right to make the card for Rosh Hashanah and the ones below for the Chinese New Year.

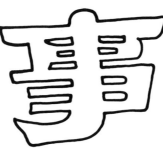

Chinese New Year

The beautiful Chinese lettering is cut in gold and mounted on traditional red for good luck.

MATERIALS YOU CAN USE
Shiny gold card stock
Shiny red card stock

1 Use a photocopier to enlarge the Chinese lettering above to the needed size. Trace the design before transferring the shapes to the card stock. Then cut them out carefully, using a mat knife and cutting mat.

2 Fold the shiny red card stock to make a plain mount. Then spray the back of the gold cutout lettering with glue and position it on the front of the card, making sure each is right side up.

STAINED-GLASS MOTIFS

The stained-glass effect works well for greeting cards with a religious theme. The design is drawn on to an acetate sheet using black outliner to represent the leading and then the special glass paints are flooded into each area.

MATERIALS YOU CAN USE
Colored pencils
Acetate sheet
Black relief outliner
Glass paints in red, blue, and yellow
Watercolor brushes
Shiny silver card stock
White scrap paper
Plain card mount

1 Trace the designs below and with colored pencils indicate roughly the colors you intend to use in each area.

2 Tape a piece of the acetate sheet over the tracing. Lay the tracings on white scrap paper so that you can see the lines very clearly. Using the black outliner, follow the lines carefully, trying to make them as even as possible. Take care not to smudge the lines as you work. Let dry for about an hour.

3 When the outliner is dry, use the glass paints to fill in each area with color. Dip the watercolor brush into the paint and then work it quickly over the acetate between the black lines. Work

The cross template on the left is suitable for christening, Easter, and confirmation cards; and the Star of David template below could be used for a variety of religious occasions, such as a bar or bat mitzvah.

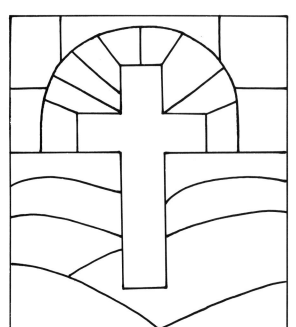

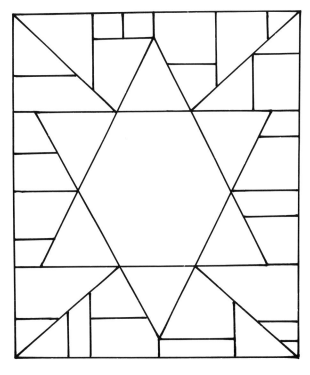

on one area at a time and use plenty of paint to give a smooth finish. Do not use too many brush strokes or you will create bubbles that may spoil the surface texture of the paint. The colors are fully mixable, so you can experiment with creating as many different shades as you wish.

4 Let the paint dry completely and then mount the design onto shiny silver card stock so that the colors show up well. Use narrow strips of masking tape to hold it in place.

5 Cut a window in the front flap of a plain card mount and glue the stained-glass panel behind it. The window should be slightly smaller than the painted area of the acetate to hide the edges and the tape.

A stained-glass card makes a colorful celebration of a religious event. A black relief outliner is used to represent the leading, and the rich glass colors are added for stunning effect.

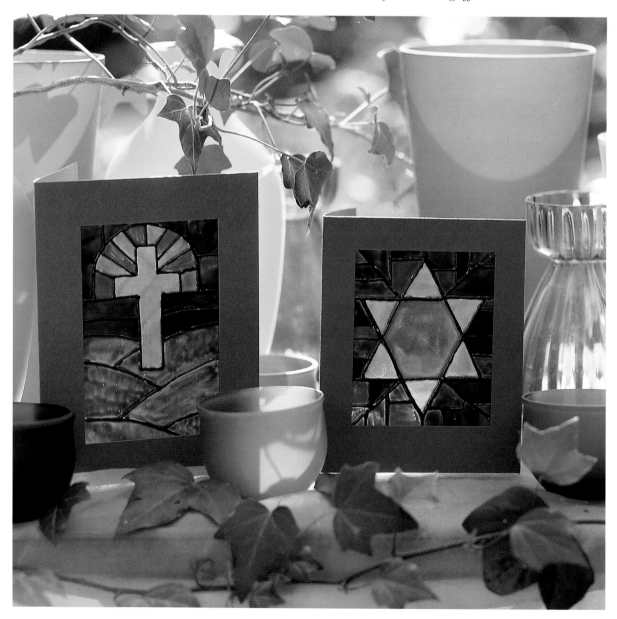

VALENTINE AND ANNIVERSARIES

Special cards to send to a loved one or to your parents on an anniversary are always welcome, especially when they are handmade. Choose a simple heart shape and be as creative as possible when you decorate it.

Hand-drawn Heart

This quick hand-drawn design (pictured at the top on page 45) is charmingly simple.

MATERIALS YOU CAN USE
Red plain card mount
White paper
Brown block printing ink
Small sheet of glass and rubber roller
Mineral spirits
Red marker and pinking shears

1 Following the instructions for mono-printing on page 59, roll some of the printing ink on to the sheet of glass and lay the white paper face down onto the ink. Now draw your design using a ballpoint pen or a sharp pencil.

2 When the drawing is complete, lift the paper off and let the print dry. Color in the center of the heart with the red marker and then cut out the paper around the design using pinking shears.

3 Spray the reverse of the design with glue and then carefully center it on the red card mount.

Homespun Valentine

Mount a heart design cut from giftwrap on to a white card and finish with some simple blanket stitching. (See photograph on page 45 bottom.)

MATERIALS YOU CAN USE
Heart design cut from giftwrap or magazine
Two pieces of white card stock
White embroidery thread
Large needle

1 Cut out the heart motif (page 126) and background, and use spray glue to mount it on to a piece of white card stock.

2 Cut this out to form a rectangle, and cut the other piece of white card stock to match.

3 Punch tiny holes all around the edge of the card front and matching holes on the left-hand edge of the card back. The holes should be about 3/8 inch apart.

4 Thread the needle with the embroidery thread and blanket stitch (see diagram overleaf) through the punched holes all around the card. Tie the thread neatly to the lower left-hand corner and work from left to right. When you reach a corner,

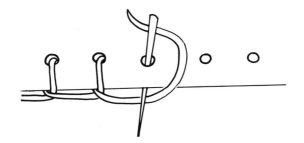

stitch into the corner hole three times to neatly negotiate the pointed edge of the card.

5 When you reach the top left-hand corner, line up the back piece of the card and stitch the last side through both layers to form the hinge of the card. Finish the stitches by tying the thread neatly at the back.

Padded Heart

A scrap of beautiful silk was the inspiration for the padded card shown opposite. The fabric is glued over a little batting and then surrounded with a heart-shaped mount. Stiff card stock holds the fabric in place.

MATERIALS YOU CAN USE
Stiff plain card mount about 5 inches square
Pink card stock
Scrap of pink iridescent silk
Scraps of polyester batting
Bronze relief paint

1 Using the smallest heart template on page 126, draw a window on the pink card stock. Use a compass to draw a slightly larger circle around this. Then cut out the circle and the heart shape with a mat knife.

2 Center this circle on the front of the folded mount and draw around the inside and outside

edges lightly with a pencil to mark the position of the batting and fabric.

3 Spread a thin layer of glue over the heart outline on the front of the card. Tear the batting into tiny pieces and place them on the glue. Lay the fabric over the top and glue the raw edges to the card. Make sure the fabric does not go outside the edge of the circle.

4 Spread glue over the back of the card stock circle and place it over the fabric. Press it down all

Use this list of wedding anniversaries as inspiration to make the perfect card for your loved ones.

1st	Paper	*	7th	Wool	*	13th	Lace	*	35th	Coral
2nd	Cotton	*	8th	Salt	*	14th	Ivory	*	40th	Ruby
3rd	Leather	*	9th	Copper	*	15th	Crystal	*	45th	Sapphire
4th	Fruit and flowers	*	10th	Tin	*	20th	China	*	50th	Gold
5th	Wood	*	11th	Steel	*	25th	Silver	*	55th	Emerald
6th	Sugar and cakes	*	12th	Silk and linen	*	30th	Pearl	*	60th	Diamond

5 When the glue has dried, decorate the edge of the circle with tiny dots of bronze relief paint.

Many different techniques can be used to make a Valentine for the one you love. With traditional red hearts or red backgrounds, the hand-drawn (top) and homespun (bottom) Valentines have a charm all their own. The soft pink padded heart on a cream background (center) makes a subtle, feminine-looking card.

around so that the padded fabric pushes through the heart-shaped hole. Let it dry, weighting the circle down all around as shown above.

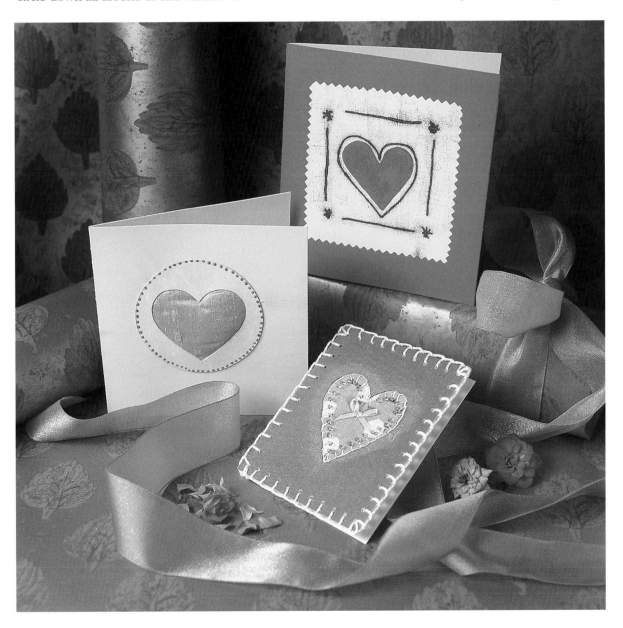

A DATE TO REMEMBER

All through the year there are festivals and holidays that call for special cards. The Fourth of July and St. Patrick's Day and are just a couple of the occasions to celebrate with a creative greeting.

Fourth of July

Choose stars and stripes to make a card that suggests both flags and fireworks.

MATERIALS YOU CAN USE
Shiny red card stock
Scraps of blue, white, and shiny gold card stock
Self-adhesive gold stars and gold extra-fine marker

1 Cut a piece of the red card stock to measure $5\frac{1}{4}$ x 12 inches. Score the card, then fold the flaps in to meet in the center.

2 Cut six strips of white card stock $\frac{3}{4}$ inch wide and 3 inches long. Using spray adhesive, glue to the front of the card to make even red and white stripes.

3 Trace the starburst design shown right. Cut the tail section out of blue card stock, and draw the lines in gold. Cut the star section from gold card stock and glue in place.

4 Glue the starburst to the left-hand flap of the card so the points of the star hold the card closed. Add gold stars following the photograph.

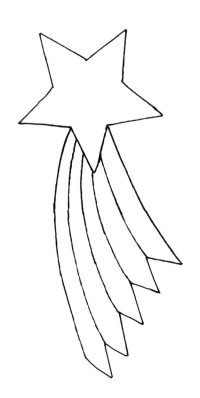

St. Patrick's Day

The Irish shamrock cards, made to celebrate St. Patrick's Day, can be seen on pages 30 and 31.

MATERIALS YOU CAN USE
Green card stock
Gold or silver extra-fine marker

1 Trace the shamrock pattern on page 126 on to tracing paper and use this to cut a shamrock template in scrap paper. Lay this on the green card stock and draw several shamrocks with a sharp pencil. Cut out the shamrocks with a mat knife. Arrange them in pairs for each card.

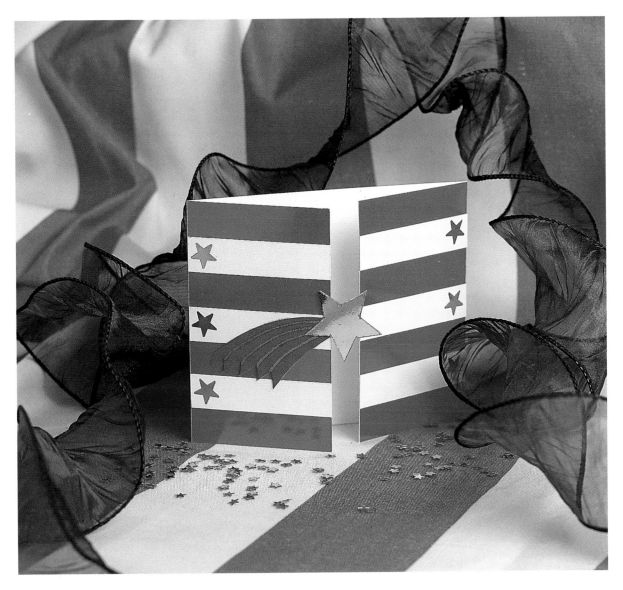

Celebrate Independence Day with a dramatic design of stars and stripes in red, white, and blue. The starburst is designed to hold the flaps of the card together.

2 Cut from the base to the center point on one shamrock and from the top to the center point on the other one. Slot the two pieces together and trim the base if necessary to enable the card to stand up.

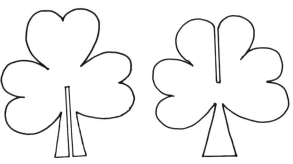

3 Unslot the two shamrocks and use the marker to decorate them. Draw a wiggly line all over one side of one to make an interesting and random-textured pattern. On the other side write a message for St. Patrick's Day. Finally, slot the two shamrocks together.

Printed Designs

Get into mass production with the following variety of printing techniques, which include using a simple potato cut, stamping and stenciling, and a few others besides. Any occasion that needs lots of cards sent out will be perfect for this treatment. Featured in this chapter are inspirational designs for wedding and birth announcements, Christmas cards, invitations, and change of address cards.

Experiment with stencils, stamping and embossing, potato prints, and linoleum cuts to make some unique cards of your own.

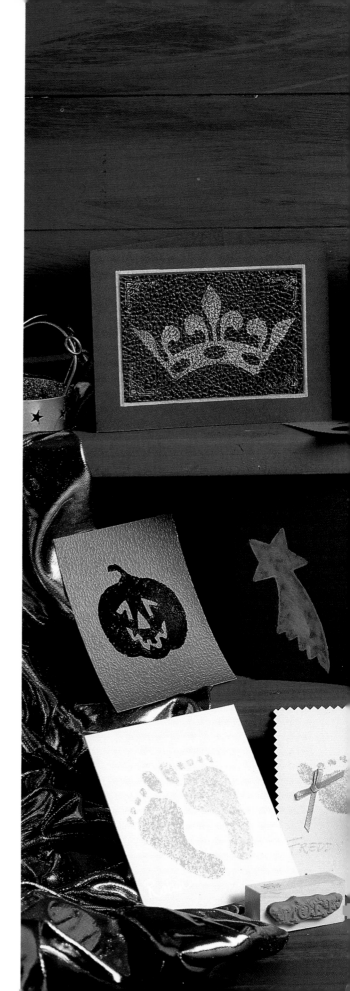

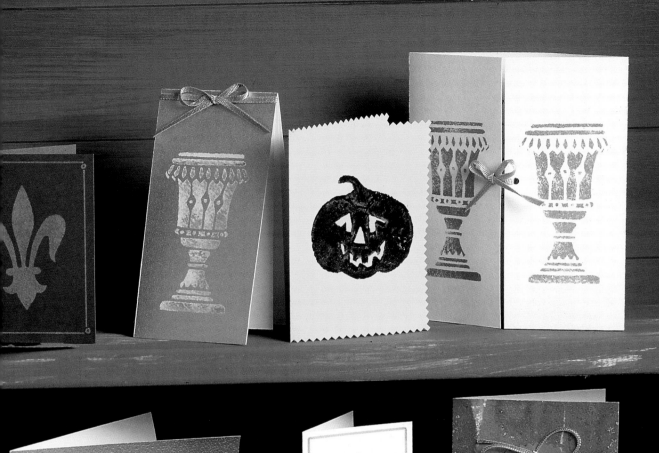

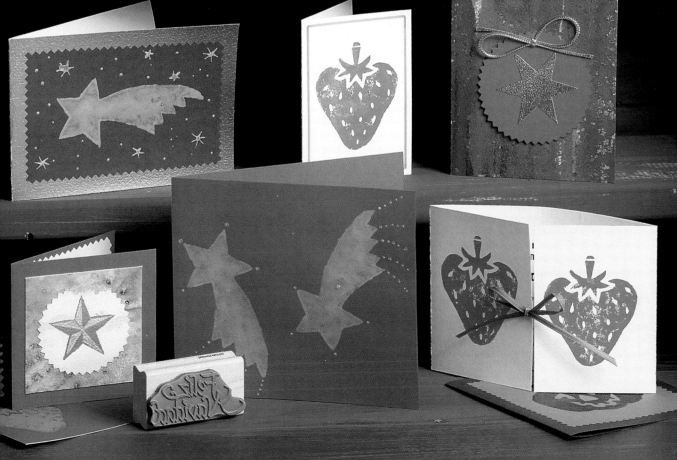

POTATO CUTS

Cut a raised shape into a halved potato. Place it on paper towels or an absorbent cloth to soak up any excess liquid. Make sure the surface of the design is completely flat or it will not print evenly.

Change-of-Address Card

Send out details of your new address using an easy potato cut featuring a house design. Two are provided here. Use one or both, as you choose. You can also stamp your design on a postcard (opposite).

MATERIALS YOU CAN USE
Large potato
Large and small kitchen knives
Watercolor brushes
Acrylic or poster paints in red and blue
White card stock
Thin cardboard
White paper
Printed name and address

1 Cut the potato in half with the large knife to give a smooth, flat surface. Place the potato cut side down on paper towels to draw out the liquid. Meanwhile, trace the house motifs from this page and transfer them onto thin cardboard to use as templates. Cut out.

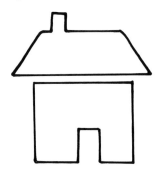

2 Lay the template on the cut surface of the potato and cut around the edge using the small knife held in a vertical position.

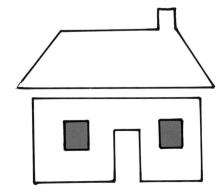

3 Scoop out the windows (shaded areas), then cut away the excess potato from around the outline, leaving a raised, flat house shape.

This simple technique can be used to create cards for many occasions. The pumpkin below, for example, makes wonderful Halloween party invitations. For a fireworks party use the starburst motif on page 46. Examples of both these cards can be seen on pages 48 and 49 .

4 Using the watercolor brushes, paint each house area with a generous coating of paint. Then turn the potato over and practice pressing it onto white paper. You may get two or three progressively paler printings before you need to apply more paint to the cut surface. If the potato cut does not print evenly, apply a little paint with the tip of the brush while the paint is still wet and blend in the edges. Tiny bare patches do not matter; in fact they add to the charm.

5 Stamp the house onto the front of a plain mount and then paste the address details inside. Or you can print the address onto paper which can then be glued on a postcard. Stamp a house at each top corner to decorate.

Anna Stone

has moved to

16 Dolley Madison Lane, Williamsburg, Virginia 23185

LINOLEUM CUTS

Linoleum cutting is an easy craft to master. Transfer your design to the surface of the linoleum and cut out with the cutting tools. The areas you want to stay white are the areas you cut away; the remaining flat areas of linoleum will have the ink rolled onto them and will print on the card. You can create flat printed areas or make textures and shading by using different cutting techniques.

Summer Party Invitations

A luscious strawberry makes an excellent motif for a summer garden party invitation. Or, if you prefer, draw your own shapes to make your own design.

MATERIALS YOU CAN USE
Small piece of linoleum
Linoleum cutting tools
Rubber rollers
Block printing ink
Heavy watercolor paper or card stock
Small piece of glass to roll out the inks

1 Trace the strawberry design below and transfer it to the center of a small piece of linoleum.

2 Use the cutting tools to cut away the background areas of the linoleum, leaving the strawberry as a raised area for printing. Cut around the outline first with a narrow cutter and then use a wider cutter to remove larger areas from the rest of the background. Lastly, use a very small cutter to cut out the tiny seeds from the surface of the strawberry.

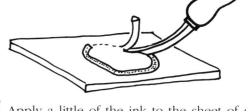

3 Apply a little of the ink to the sheet of glass and use the roller to disperse the ink evenly over the surface of the roller. Run the inked roller over the linocut several times until the surface is evenly coated with ink.

4 Lay the paper or card stock over the linoleum, and use a clean roller to roll over the back of the paper to make the print. Peel the paper off carefully and let the print dry. You may need to practice on scrap paper to get just the right amount of ink and pressure. Ink the linocut in the same way for each subsequent print.

5 When the prints are dry, score and fold the cards to complete the invitations as for the stenciled wedding cards on page 57.

To position the linocut accurately on your cards lay strips of masking tape on the work surface marking the position of the linoleum and paper. This will ensure that you place both accurately each time you print. Try a test print. Adjust taped lines and cut the rest of the paper to the right size and position it on the linoleum as if making an identical print.

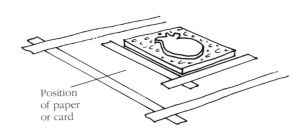

Position
of paper
or card

Use the strawberry design to print place cards as well as invitations.

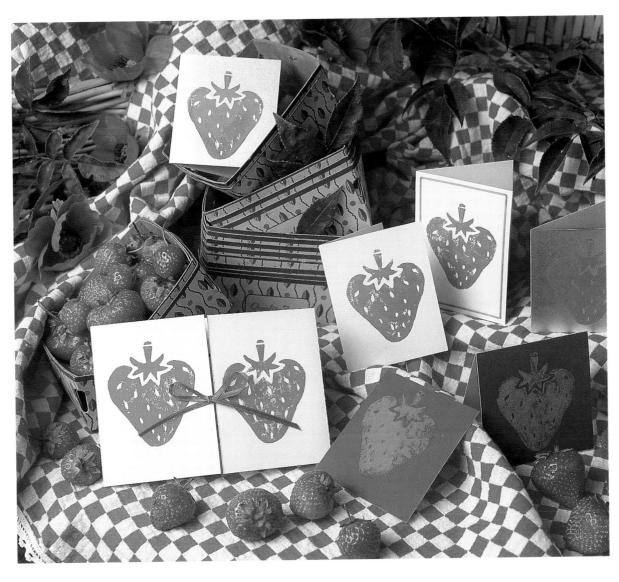

STAMPED AND EMBOSSED CARDS

Using a stamping and embossing technique is an ideal way of making a quantity of cards with very professional results. You can either use a greeting message stamp or, for a more luxurious look, make a white lining sheet to fit inside.

Embossed Designs

Choose a stamp design from the wide range available. Embossed cards, such as the two designs pictured on the left of the top shelf in the photograph on pages 48–49, look sophisticated and could be used for many occasions.

MATERIALS YOU CAN USE
Thin card stock in colors of your choice
(plain or decorated – see page 94)
Fine gold marker
Rubber stamps
Stamp pad
Embossing ink
Embossing powder

1 Roughly cut out pieces of card stock; your measurements need not be accurate at this stage. Squeeze some embossing ink onto the surface of the dry stamp pad. Spread it evenly and then close the lid and allow the ink to sink into the fabric for about 15 minutes.

2 Press the decorative rubber face of the stamp onto the surface of the pad for an even layer of ink. Press the stamp firmly onto one of the pieces of card stock. Lift off carefully to avoid smudging.

3 Sprinkle embossing powder liberally onto the stamped area and tap the edge of the card to distribute it evenly. Shake the excess powder off onto scrap paper. This can then be returned to the jar for further use.

4 Hold the stamped card very carefully near a heat source, such as a hot plate or special heat gun, until the powder melts and becomes shiny. This gives an attractive and permanent embossed finish. Do not allow it to overheat, but make sure the powder is melted all over the design or it could brush off.

5 Trim the motif and glue it on to a plain mount. Add a border with a gold marker.

Stamped Designs

The cards (shown opposite and bottom center on pages 48–49) are quick and simple to make. Add as much extra decoration as you like to personalize each one.

MATERIALS YOU CAN USE
Rubber or sponge stamps
Sponge roller
Stamping ink
Colored card stock and plain card mount

1 Pour a little of the stamping ink onto an old plate, then coat the roller evenly. Cover the surface of the stamp with ink by rolling back and forth. Do not press hard on the roller or too much ink will be deposited on the stamp, filling in the indentations, and the resulting printed design will not be clear.

2 Practice on different scrap surfaces until you are confident and can apply just the right

amount of ink. Then, to print the design, press the stamp firmly against your chosen card stock. You will need to recoat the stamp for each impression. Work on small pieces of paper, and then cut out or use the hand-torn edge technique (see page 11) to mount these onto the plain card mount.

3 To position your stamps accurately on a ready-cut card use small pencil marks or strips of masking tape to line up with the wooden edge of the stamp block.

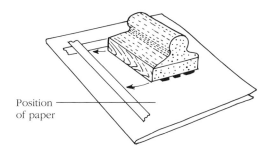

Position of paper

Commercially available rubber stamps can be used to make attractively designed cards, such as these two, quickly and in large numbers.

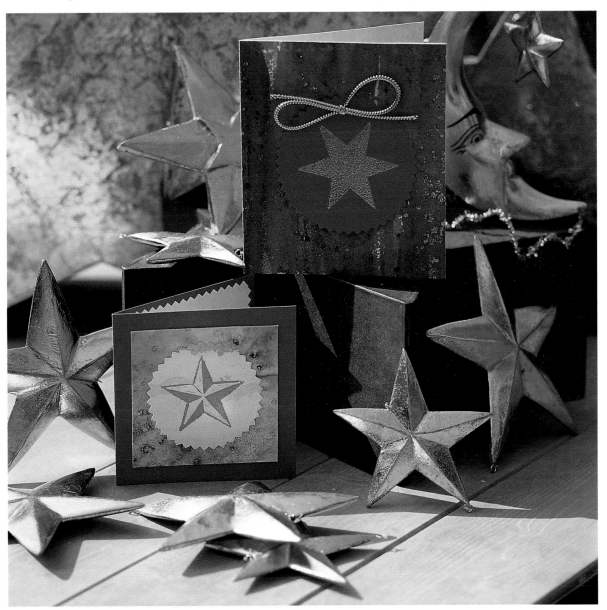

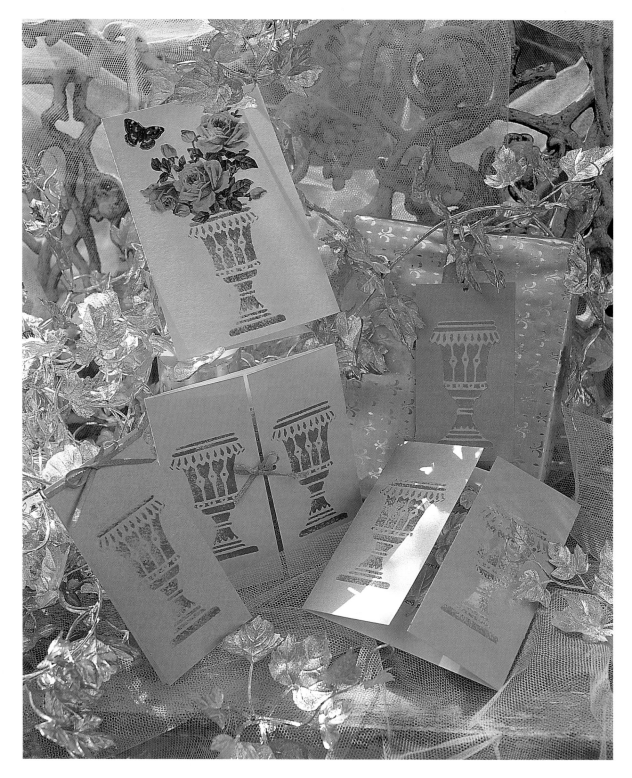

Subtle silver and white are always right for weddings, and these elegant urns look particularly fine when used in pairs—one each for the bride and groom—on invitations or singly on menu, gift, or greeting cards. Narrow silver ribbon adds the finishing touch.

STENCILED CARDS

The stencil is made on an acetate sheet, which is then taped to the paper, and painted over with fast-drying paints. Simple shapes work best, as every part of the design needs to be connected to the main area of acetate by little "bridges," or thin strips.

Wedding Stationery

A classic stencil like this elegant urn will look just right printed on silver or white card stock for invitations, cards, and menus.

MATERIALS YOU CAN USE
Acetate stencil sheet
Fine black waterproof marker
Acrylic paints in white and gray or silver
Small stencil brushes
Silver or white card stock

1 Tape a piece of stencil acetate over the template on this page. Trace the urn design, using the marker, onto the acetate.

2 Using a mat knife and cutting mat, carefully cut away the shaded areas. Be careful not to cut from one area to the next or you will weaken the stencil and the design will be spoiled. If you do accidentally cut one of the bridges, cover it with masking tape and cut out the areas again.

3 For the invitations, cut pieces of silver or white card stock 12 x 7 inches. Score two lines 3 inches from and parallel to the short sides. Fold these over to make the front of the card.

4 Using masking tape, secure the stencil on one side of the card front. If you are using a silver card, paint all over in white, let dry for a few moments, then use a clean brush to add shading here and there in gray. Repeat the stenciling on the other side of the card front. If you are using white card stock, stencil the two urns in silver.

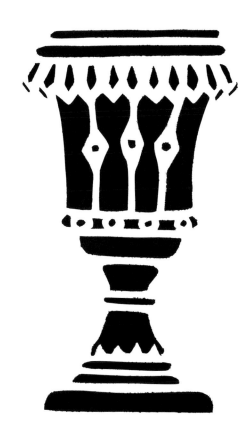

5 Make the place cards, menu cards, and other cards in the same way.

To use the urn stencil for other occasions, print it in shades of terra-cotta and glue on flowers and a butterfly.

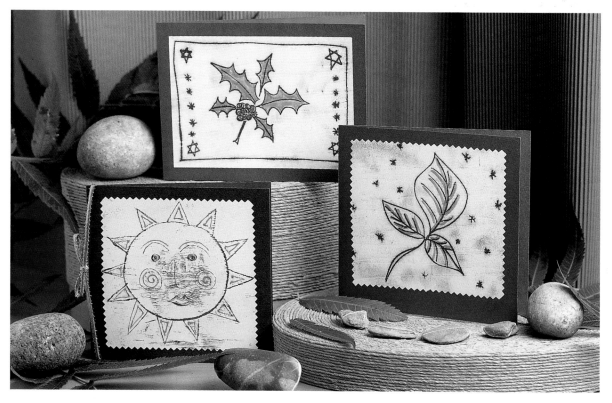

The technique of mono-printing (facing page) is easy to master, and, with a little help, even the younger members of the family could try their hand at a simple motif, such as a sun or holly leaf.

Birth Announcements

You can make these cards (pictured on page 48) before the big event; just add a bow in the appropriate color and fill in the details. Or wait until the baby has arrived and design it with him or her in mind. The baby's name, weight, and birthday can be handwritten with colored, gold, or silver markers or printed.

following the outlines carefully. Tape the stencil to white, pink, or blue card stock, and apply the paint with a small marine sponge. Dab it on lightly to make a soft, dappled texture. Try peach paint on white paper or white paint on the pink or blue paper.

MATERIALS YOU CAN USE
Acetate stencil sheet
Fine black waterproof marker
Acrylic paints in white or peach
Small marine sponge
Pink, blue, or white card stock
Narrow ribbons

1 Lay a piece of stencil acetate over the footprint shown. Trace and cut the stencil,

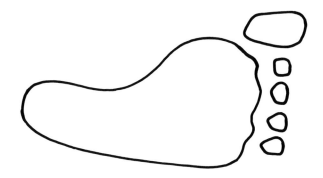

ONE-OF-A-KIND PRINTING

If you like the printed image and you want to make a one-of-a-kind card, try monoprinting. This easy technique involves simple freehand drawing on the back of paper that has been laid over a piece of glass rolled with a thin layer of ink.

Monoprints

Choose simple shapes to draw for monoprinting. You can create several similar designs—yet they all will be different (see facing page for examples).

MATERIALS YOU CAN USE
Block printing ink
Small sheet of glass
Rubber roller
White paper
Mineral spirits
Colored card stock
Colored, gold, and silver markers

1 Put some of the printing ink onto a sheet of glass and use the rubber roller to spread it out evenly to a rectangular shape. The ink should form a thin layer so that you can still see the glass through it slightly.

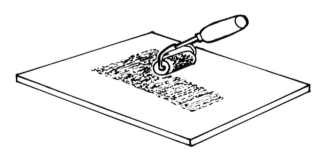

2 Very lightly lay the paper face down into the ink. Now draw your design using a ballpoint pen or a sharp pencil. Take care that your hand does not rest on the paper as you draw or you will spoil the print.

3 When the drawing is complete, lift the paper off carefully and let the print dry in a warm place. Make sure the ink is quite dry before you make the print into a card or you may smudge the design.

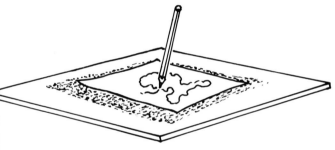

4 For a decorative effect, cut around the edge of the monoprint with pinking shears. You could also color in areas of your drawn design with markers. Use spray adhesive to glue your decorated monoprint to the front of a folded piece of card stock.

If you are a bit shaky about freehand drawing, you can draw your monoprint design on the back of the card first, then go over these lines to make the finished print. Children's drawings look particularly good printed in this way, as their naive quality is fresh and charming.

CHAPTER 5

Hand-sewn Cards

*M*aking a hand-sewn card requires special care, which is bound to be appreciated by the recipient. The variety of sewing and embroidery techniques includes cross stitch, needlepoint, silk ribbon embroidery, and patchwork, and will give both the experienced stitcher and those new to the delights of needlecraft something to try their hand at. The following projects use sewing skills that are easily mastered and give very impressive results.

The wide variety of sewing techniques described in this chapter can be used to create the range of exquisite cards displayed here. These techniques include, clockwise from top right, patchwork (page 71), silk ribbon embroidery (page 62), cross stitch (page 68), another four examples of silk ribbon embroidery (page 62) and needlepoint (page 74).

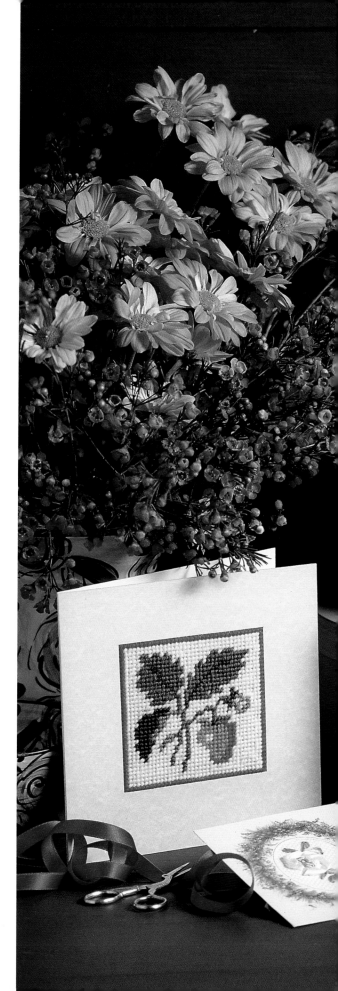

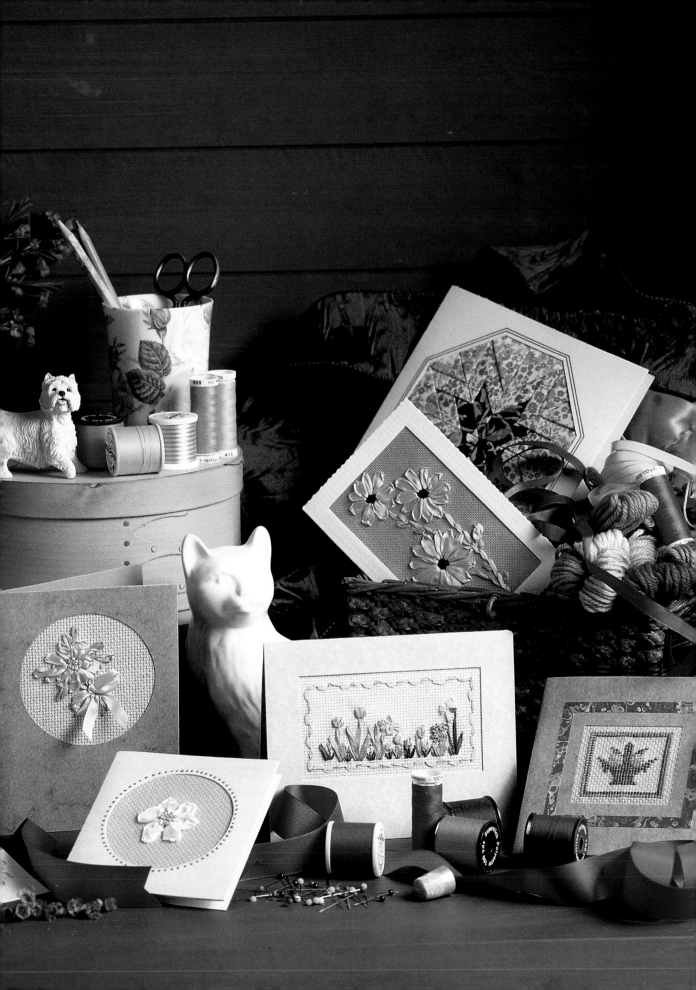

SILK RIBBON EMBROIDERY

Embroidering with fine silk ribbon is a beautiful needlework technique. Because the ribbon is wider than floss, the embroidery develops much more quickly. A simple design, such as a single rose, takes only a few minutes to complete and so is perfect for a last-minute card.

Basic Techniques

Once you have mastered the techniques and familiarized yourself with the particular stitches explained here, you will be ready to begin the silk ribbon embroidery projects featured on pages 64–67. Gather together the few simple materials required and practice on a test piece of your own before beginning one of the designs provided.

MATERIALS YOU CAN USE
Open weave linen or cross stitch embroidery fabric
in the color of your choice
Silk ribbons in widths and colors of your choice
Needles – chenille size 18 and crewel size 8
Embroidery floss
Disappearing marker

1 In order to thread and secure the ribbon, cut it at an angle to make a point. Thread the point through the eye of the chenille needle and pull it through a little way. Push the point of the needle back into the ribbon and push this up toward the eye to make a loop.

2 Pull the short free end of the ribbon through the eye to eliminate the loop. Then hold both ends of the ribbon together behind the needle so that the eye of the needle is covered and the ribbon is securely held. This helps the ribbon to pass through the fabric easily and prevents it from slipping off the needle while stitching.

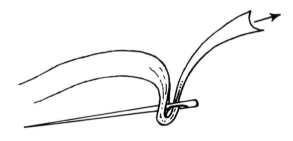

3 Keep the stitch tension fairly loose and even when working with silk ribbon. This allows the ribbon to form the petals in a natural way and still retain a three-dimensional effect. The wider the ribbon, the looser the tension should be.

4 To stop the stitches from twisting, hold the ribbon down on the right side of the fabric as you make a stitch and pull it through to the back, taking any twists through to the wrong side.

5 To finish, sew down the ends on the wrong side using the crewel needle and floss.

The tension and varying widths of ribbon that you use for each stitch will give totally different results. It is worth experimenting on small pieces of fabric before starting a larger design so that you know what the finished results will be. These experimental pieces can be made into delightful small cards with the use of decorated window mounts.

Mark your designs on the fabric using a disappearing marker. This leaves a faint blue line to guide your stitches. Any marks still showing after stitching will eventually fade or can be removed with a watercolor brush dipped in clean water.

These are the basic stitches you will need to complete the projects on the following pages.

Ribbon stitch

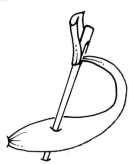

Bring the ribbon up through the fabric, hold it flat, and insert the point of the needle back into the fabric through the center of the ribbon. Pull gently to make a softly curled petal in one stitch.

Stem stitch

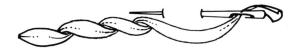

Work with a forward and backward movement, keeping the stitches the same size and the ribbon to the left of the needle as shown.

Zigzag border

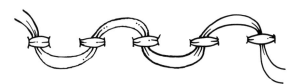

Make a row of well-spaced running stitches in one color. Weave even-sized loops in and out of the stitches, using a contrasting ribbon, without stitching through the fabric.

Chain stitch

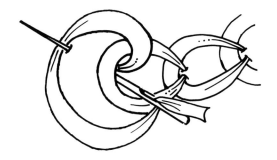

Keep the links of the chain even with regular-sized stitches. Do not pull the ribbon tight or the fabric will pucker and the ribbon will be crushed.

Lazy daisy stitch

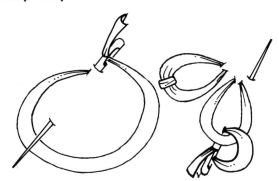

Work as chain stitch but make separate stitches; hold the loops in place with a small stitch.

French knots

Hold the ribbon taut on the surface of the fabric with the free hand, twisting the needle around it once or twice. Tighten the twists, then insert the point back into the fabric and pull the needle through to the back of the fabric.

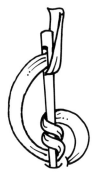

Spring Flower Border

Delicate silk ribbon is perfect for representing fresh flower petals (facing page). Use a variety of flowers in different colors and add green stems.

MATERIALS YOU CAN USE
Open-weave linen or cross stitch embroidery fabric in the color of your choice
Silk ribbons in widths and colors of your choice
Needles – chenille size 18 and crewel size 8
Disappearing marker
Card stock for a window mount

1 Draw a horizontal base line about 3½ inches long on your chosen fabric. Mark the position of the flowers and leaves growing up from the base line using disappearing marker. Lightly mark a border measuring about 4 x 2 inches.

2 Stitch the flowers first with straight stitches and lazy daisies for daffodils, straight stitches for tulips, lazy daisies for crocuses, and French knots for hyacinth (see stitch diagrams on page 63).

3 Stitch the stems and leaves for the flowers in straight stitch using narrow ribbons.

4 For the zigzag border, follow the line you have already marked, making a row of small, widely spaced running stitches in a narrow ribbon. Using a medium-width contrasting ribbon, weave in and out of this row of running stitches to form a two-tone border. Take particular care to keep these stitches flat.

5 Choose a lightly patterned cream card stock to make a window mount, cutting an oblong window to fit around the design. Mount as described on pages 11 and 12, using spray glue to enclose the edges of the fabric.

White Briar Rose

The white briar rose on page 66 (bottom) is set off nicely against the pale green fabric. Choose your own colors or follow the suggestions given here. Decorate the window with bronze outliner.

MATERIALS YOU CAN USE
Open-weave linen or cross stitch embroidery fabric in pale green
Wide and narrow silk ribbons in colors of your choice
Needles – chenille size 18 and crewel size 8
Disappearing marker
Bronze relief outliner
Card stock for a window mount

1 For a white briar rose, work on pale green fabric about 4 inches square. Mark the fabric with a center point and then five equally spaced radiating lines around this, about ¾ inch long. Following the stitch diagrams on page 63, make five ribbon stitches on the marked guidelines, using wide white ribbon.

2 Using a narrow pink ribbon, fill the center of the flower with large and small French knots to complete the design.

3 Trim the fabric about 1¼ inches from the embroidered area. Tape the embroidery behind a 3-inch-diameter circular opening in the center panel of a window mount. Make sure the image is centered in the window. Fold over and glue the left-hand panel of the card behind the embroidery to enclose the fabric and form the finished greeting card.

4 Decorate the edge of the window with a simple row of dots made with the bronze relief outliner. Let dry before writing message inside.

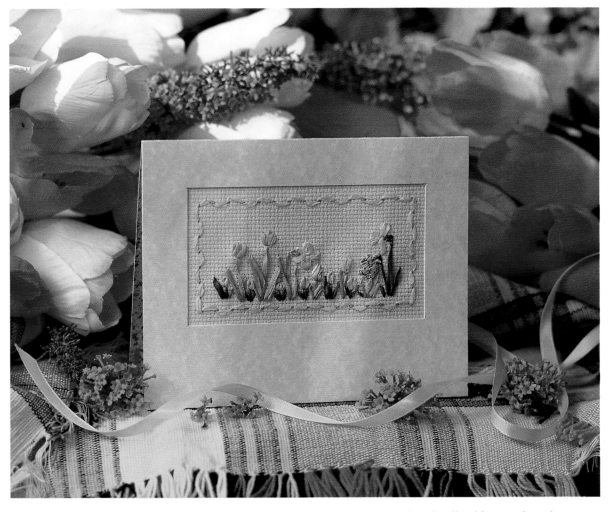

The spring flower border card shows the delicate results achieved with silk ribbon embroidery.

Cream and Pink Rose

The cream and pink rose (on page 66 top) has peach-colored French knots at the center.

MATERIALS YOU CAN USE
Open-weave linen or cross stitch fabric in white
Wide and narrow silk ribbons in colors of your choice
Needles – chenille size 18 and crewel size 8
Disappearing marker
Card stock for a window mount

1 Work on a piece of white fabric about 4 inches square. Following the chain stitch diagram (page 63), work the center of the rose in a few small chain stitches to form an oval. Use narrow pink ribbon for these stitches and fill in the center with tiny peach-colored French knots.

2 Work the outer petals in a wider, cream-colored ribbon using a spiral of chain stitches to form the rose shape.

3 Lastly, work a loose lazy daisy stitch in narrow green ribbon to represent each leaf.

4 Make a decorated window mount with an oval window about 2¹/₂ inches long (see pages 11–12).

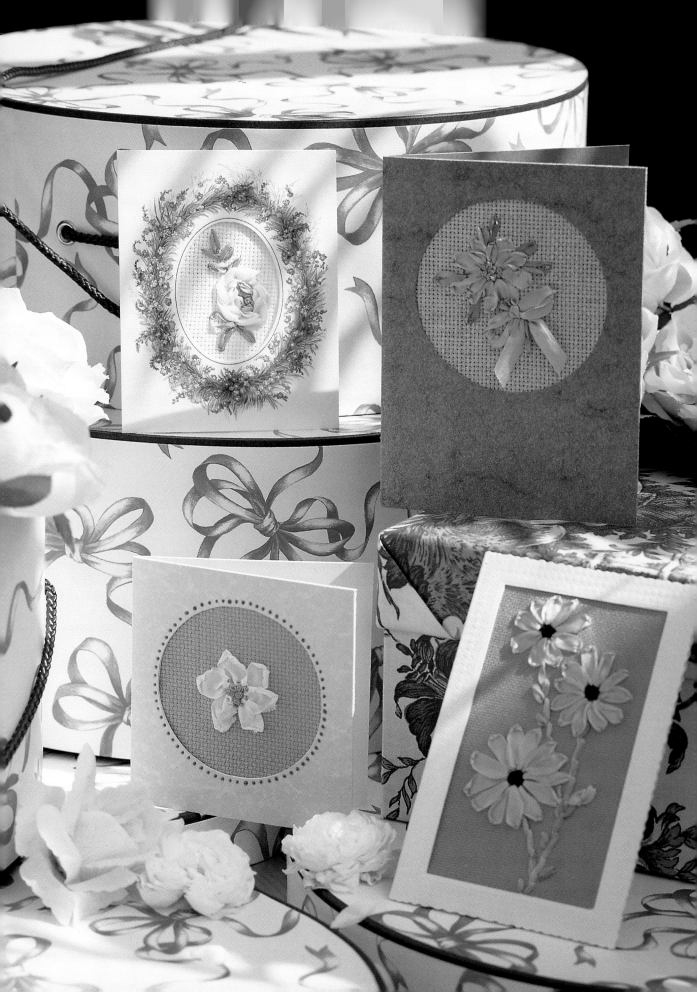

Mauve and Blue Rose

The mauve and blue rose, opposite, is worked in the same way as the white briar rose. A silk ribbon bow, leaves and extra petals are added to this design to make it slightly different.

MATERIALS YOU CAN USE
Open-weave linen or cross stitch embroidery
fabric in cream or beige
Wide and narrow silk ribbons in colors of your choice
Needles – chenille size 18 and crewel size 8
Disappearing marker
Card stock for a window mount

1 Work on a piece of fabric about 4 inches square. Mark the rose as before but drawing guide lines for nine petals, and work this outer layer of petals in blue ribbon stitch using a wide ribbon.

2 Now add a second, inner layer of petals in mauve ribbon stitch. Then fill the center of the flower with French knots made from narrow deep mauve ribbon. Use narrow ribbon in two shades of green. Work lazy daisy stitches in one shade to create leaves and straight stitches in second green to make stems.

3 To make the bow, first create the two loops by working large lazy daisy stitches using a wide blue ribbon. Make sure that the loops are the same size. Make a single loose running stitch in the center to form the knot. Then carefully bring the ribbon out from the center of the bow under the knot and cut off the end to make a tail. Make another tail in the same way and trim them both at an angle to complete.

Blue Daisies

Daisies (opposite) look stunning stitched in wide blue ribbon with black centers. They are set off against a deeper blue background.

MATERIALS YOU CAN USE
Open-weave linen or cross stitch embroidery fabric in blue
Wide and narrow silk ribbons in colors of your choice
Needles – chenille size 18 and crewel size 8
Disappearing marker
Card stock for a window mount

These beautiful silk ribbon embroidered designs can be mounted in a variety of ways. Pictured here are the cream and pink rose (top left); white briar rose (bottom left); mauve and blue rose (top right); and blue daisies (bottom right).

1 Mark the center points of three daisies and draw a faint circle around each. Make radiating lines to mark the petals. Then draw in the stems.

2 Stitch the daisy petals in long ribbon stitches using wide blue ribbon. Fill the center of each flower with several carefully placed straight stitches in narrow black ribbon.

3 Work the stems in stem stitch, using a narrow shaded green ribbon. Add small side leaves and a blue bud worked as lazy daisy stitches.

4 This card was framed in a slightly different way from the others. To complete it, carefully glue the embroidery to a piece of card stock. Using a plain mount, cut a window in the front to fit your embroidery. Trim the backed embroidery to fit the card and glue in place behind the window.

CROSS STITCH

Cross stitch is one of the simplest stitches to master, particularly if you work on a special evenweave fabric such as Aida, which consists of a grid of tiny woven blocks interspersed with holes. To make a cross stitch, bring the needle up through a hole in the fabric and make half the stitch by inserting the needle back through a hole diagonally adjacent to the first. Finish the cross stitch by working a diagonal stitch in the opposite direction, crossing the first. To stitch a row, make a line of diagonal half stitches and complete them when you stitch the return journey (see diagram below left).

Valentine Cross Stitch

This charming card with its plaid border and cross stitch heart (opposite) is quick and easy to make.

MATERIALS YOU CAN USE
Small piece of 14-count white Aida fabric
1 skein of red DMC (No. 304) stranded embroidery floss
Tapestry needle, size 22
Colored or white card stock
Plaid fabric for the border
Fusible web

1 Divide the embroidery floss and use two strands at a time. Use pieces about 20 inches long to avoid tangling. Make all your stitches cross the same way. Following the chart and stitch diagram on this page, work the heart design in the center of the fabric. Each square on the chart equals one block of threads on the fabric, and each symbol equals one stitch.

2 Before you insert the design into the card, press the embroidery carefully. Lay it face down on a piece of clean cotton fabric. Lay a similar piece on top and press with a steam iron until it is flat.

3 Spray the back of the embroidery with adhesive and then mount it, centered, onto the front of a square folded card.

4 Make a window from plaid fabric to frame your cross stitch heart. Iron fusible web to the back of the fabric to prevent the edges from fraying. Mark out the area of the window and cut it out carefully with sharp scissors. Use the lines of the plaid weave as guides to keep the edges straight. Cut the outer edges of the fabric with pinking shears to fit just inside the edges of the front of the card and glue it in place with spray adhesive.

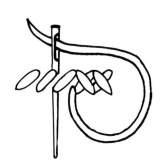

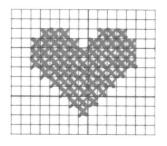

Cross stitch heart chart

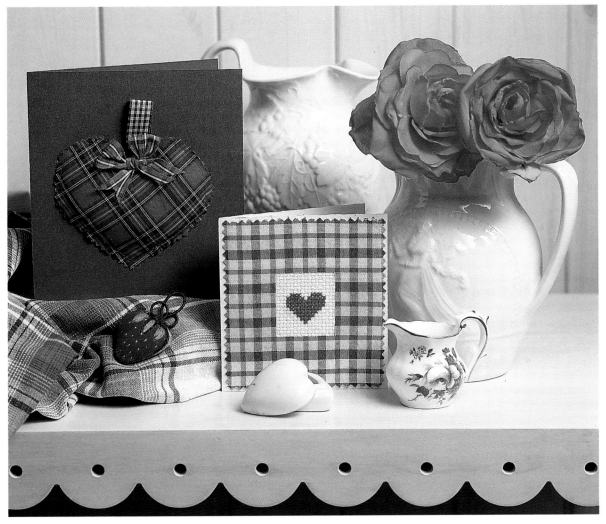

The Valentine cross stitch is pictured here with a pretty padded heart card (see page 44).

Cross Stitch Garden Basket

The basket design (following page) makes a pretty card that can be turned into a keepsake.

MATERIALS YOU CAN USE
5 inch square of 14-count pale green Aida fabric
DMC stranded embroidery floss as listed in key
Tapestry needle, size 22
Marbled paper for the mount
Window mount card 5 inches square
Adhesive

1 To stitch the design, follow the chart and color key on page 70, referring to step 1 of the Valentine cross stitch for the basic technique. Then press the embroidery between two clean pieces of cotton with a steam iron.

2 Cut a square window in the center section of the window mount to fit around the outside of the embroidered border. You can cut it to fit exactly or leave a fabric border all around the edges.

3 Trim the fabric to a $4^{1}/_{4}$-inch square, and tape it, centered, behind the window, stretching the fabric evenly. Cover the back and center section of the card and spray adhesive on the

inside of the front flap. Then fold this in place to enclose the back of the embroidered fabric.

4 To make the decorative border, cut four strips of the harmonizing marbled paper about ³/₈ inch wide. Cut the pieces longer than the sides of the window to allow for the mitered corners. Spray the reverse side of the strips with glue and then place them around the window.

5 Using a ruler and mat knife, carefully cut the miters at the corners, going through both thicknesses of paper to make a perfect join (see page 12, step 3). Remove the excess pieces of marbled paper and press the corners down firmly to adhere them to the card.

Your cross stitch card could be slipped into a frame to keep as a memento when the occasion has passed.

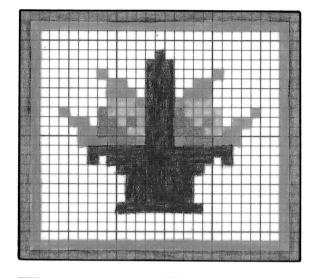

402 Gold 987 Green

721 Orange 433 Brown

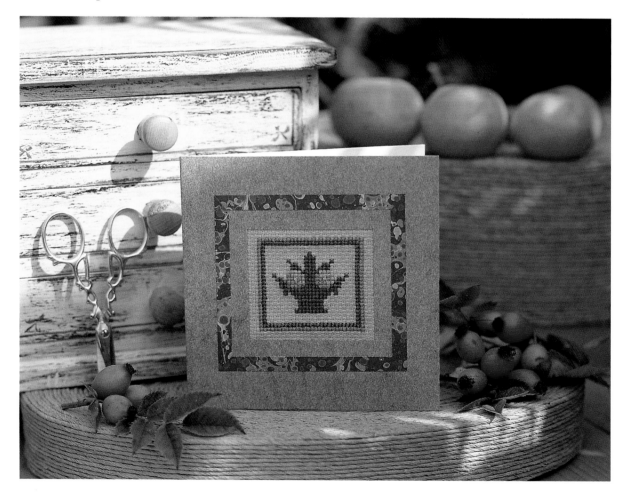

PATCHWORK

This star patchwork technique needs accurate folding but very little sewing. It is built up of small squares of fine fabric folded into triangles and arranged in concentric circles to form a star shape. The raw edges are hidden behind a window mount to give a smooth, professional finish.

Traditional Fabric Star

Patchwork fabrics are used to make this beautiful card (shown on page 72, bottom), which later could be framed and turned into a picture.

MATERIALS YOU CAN USE
Scraps of three differently patterned fabrics
Scrap of unbleached muslin for backing
Piece of cardboard, 4¾ inches square
Matching threads
Sewing needle
Fine silver marker
Window mount card

1 Decide on the position of the three fabrics in your star design and then cut out the pieces in the following way. Using the cardboard as a template, mark and cut out four squares from the center fabric and eight squares from each of the two remaining fabrics.

2 Fold the squares of Fabric 1 exactly in half, with right sides outside, and press each fold. Bring the folded edges in to meet at the center, thus forming a triangle. Press the folds again.

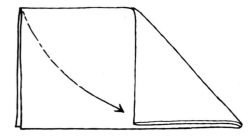

3 Cut the muslin to an exact 6-inch square and mark lines on it accurately in pencil as shown below, to use as a positioning guide.

4 Pin the four central triangles in place with the first folds showing. Line up the second set of folds on each triangle with the diagonal marked lines on the muslin backing and butt them together so that none of the muslin shows between them. Make tiny invisible stitches at the center points of the triangles to secure the fabric to the backing and then sew the raw edges to the backing with running stitches.

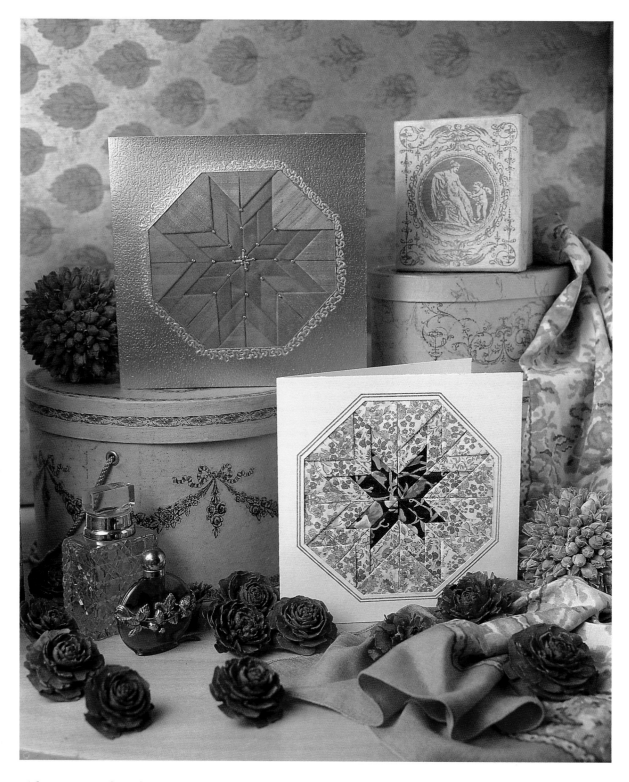

The same patchwork technique creates different effects when a variety of solid-colored and patterned fabrics are used. The rich red star is made with a gorgeous assortment of colored silks embellished with beads, but a delightful traditional look can be achieved with patterned patchwork fabrics.

5 Take the second set of triangles (Fabric 2) and place each piece on one of the radiating lines on top of the first set of triangles. Place all the points 3/4 inch from the center (see diagram below). Stitch the points to secure them and sew in place with running stitch, close to the new edges.

6 Position the final row of triangles (Fabric 3) around the backing fabric, as before, leaving about 5/8 inch of each previously placed triangle showing. Stitch this row of triangles in place.

7 Draw an octagonal shape to fit around the finished patchwork. Cut out a window to this shape on the center panel of a window mount card. Tape the patchwork, centered, behind this window and then trim the fabric to fit just inside. Fold over and glue the left-hand panel of card behind it to enclose the fabric.

8 Using the silver marker, draw two parallel lines around the window mount to make a decorative border.

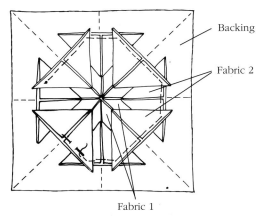

Backing

Fabric 2

Fabric 1

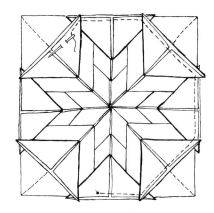

Jewel-colored Silk Star

This star is made in the same way as the previous project but uses an assortment of richly colored silks and is embellished with beads.

MATERIALS YOU CAN USE
Small pieces of three different-colored silks
Scrap of unbleached muslin for backing
Gold seed beads
Four gold bugle beads
Thread to match the bugle beads
Fine needle
Textured gold window mount card
Gold relief outliner

1 Decide on the position of the three different-colored silks, then follow the instructions on pages 71 and 73 to make the patchwork star.

2 Stitch a gold seed bead to the center of the star and then stitch the four bugle beads around this, following the lines of the patchwork. Attach more gold seed beads to the inverted points of the star to give a little extra sparkle and to add texture to your design. Make sure that you have fastened off all the threads securely at the back of the fabric so that the beads do not fall off.

3 Cut an octagonal window in the center section of your window mount. Mount the star behind the window and use spray adhesive to glue the left-hand panel over to hide the back of the fabric. Using the gold outliner, draw a wiggly border about 3/8 inch wide all around the edge of the mount.

NEEDLEPOINT

A small needlepoint design can easily be made into an attractive greeting card. Choose from a handful of simple stitches and create a miniature masterpiece.

Basic Stitches

First, cut your yarn into manageable lengths; about 18 inches is ideal. Choose which of these basic stitches you prefer to work the design in, and then begin. You could use a combination of all of these stitches to suit the size of the area to be worked.

Half cross stitch

This stitch is worked horizontally and uses the least amount of yarn. However, if worked without a frame, it has a tendency to distort the canvas, which means that the finished piece must be dampened and reshaped.

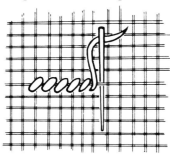

Continental tent stitch

This uses more yarn than half cross stitch, as it makes a longer diagonal on the back of the work.

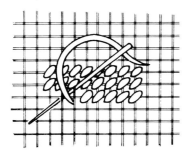

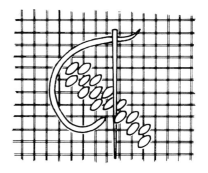

Basketweave tent stitch

This stitch is worked diagonally and causes the least distortion of the canvas. It is therefore ideal for the larger background areas.

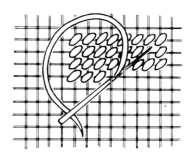

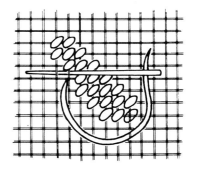

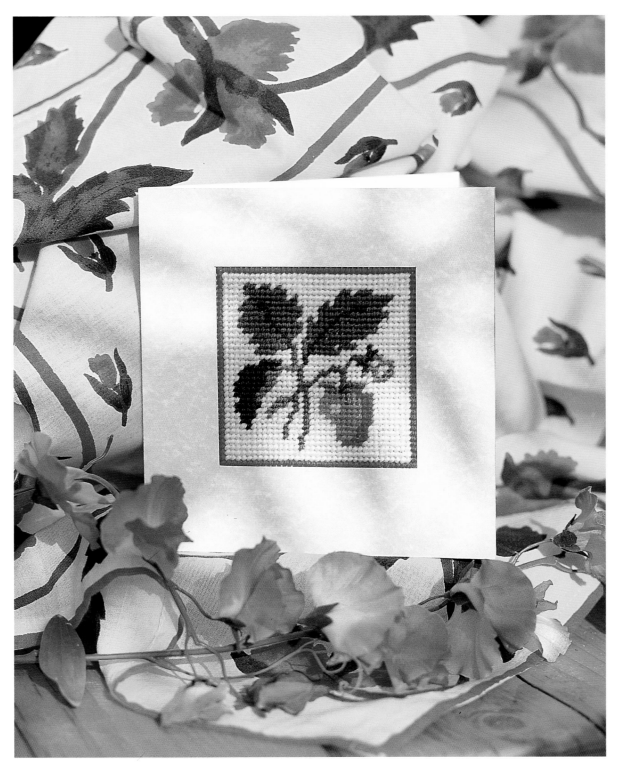

*Choose this luscious strawberry design to stitch into a charming card (instructions begin on page 76).
A summer birthday or anniversary would be the ideal occasion. You could also make it up into a
picture or pincushion to send as a gift.*

Strawberry Sampler

The whole surface area of the canvas is covered in the charming strawberry design shown on the previous page. The colors of yarns listed below form the key. The stitched area of the design measures about 3¾ inches square.

MATERIALS YOU CAN USE
DMC Tapisserie yarns – one skein of each as follows:
Dark green – No. 7428
Mid green – No. 7376
Light green – No. 7404
Dark red – No. 7600

Light red – No. 7135
Pink – No. 7132
Background color – Ecru
6-inch square of single-thread, 10-count white evenweave canvas
Tapestry needle, size 24
Posterboard for mount (about 6 inches square)
Plain mount card

1 Mark the center of the canvas, both vertically and horizontally, with a line of basting where the arrows are on the chart. Each square on the chart represents one stitch on the canvas. Count

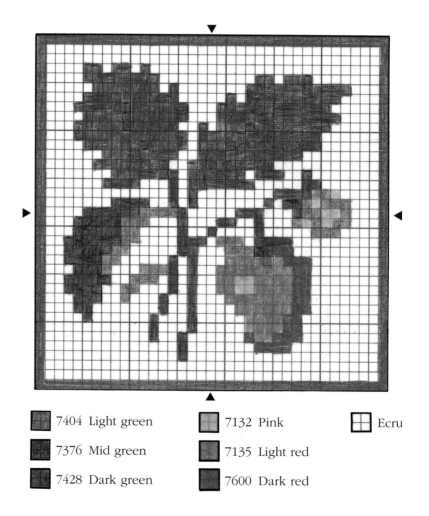

	7404 Light green		7132 Pink		Ecru
	7376 Mid green		7135 Light red		
	7428 Dark green		7600 Dark red		

the squares, then baste around the outer edge of the design also. Do not be tempted to mark the canvas with a pencil line, as this will rub off on the yarn and discolor it. Start stitching in the center of the design and work out toward the edge, finishing with the background. This is the best way to use a charted design to avoid making mistakes in counting the squares.

2 Following the chart, stitch the design using the colors in the key. Begin by bringing the yarn up from the underside of the canvas. Leave about 2 inches of yarn at the back and hold this in place while you make the first few stitches over it. To finish, weave the thread behind two or three stitches. You can move to another area of the same color without fastening off the yarn, but this next area should be no more than 3/4 inch away.

Try to keep the stitch tension moderate. You should aim for a smooth, even look, so that the yarn is not so tight that the canvas shows through, nor so loose that the stitches are suspended above the front of the canvas.

3 You may need to stretch the canvas after stitching to ensure that it is square for mounting. For this you will need a piece of particleboard, a right-angle triangle and ruler, a spray bottle, several sheets of clean white blotting paper, and thumbtacks or a staple gun.

Start by spraying the back of your needlepoint with water so that it is very damp but not soaking wet. Lay the sheets of blotting paper out on the particleboard and spray them lightly with water. Place the needlepoint face down on the

blotting paper and pull it into shape with your hands. You may have to pull very strongly; then check the accuracy with the triangle and ruler. Tack or staple through the canvas along one edge, stretching it as you go. Now tack the opposite edge, pulling it very taut. Tack the other two sides in the same way, starting at the center on each side and working out toward the corners.

Lightly spray the whole surface of the needlepoint and then leave it in a warm place to dry gently for one or two days. Do not be tempted to dry it too fast against a radiator or you may damage the work.

4 Measure your finished needlepoint and cut a window mount from posterboard to fit exactly around the edge of the stitching. Tape the canvas behind the window and then mount this onto the front of a folded card cut to the desired size.

If you like the design but don't want to stitch it yourself, you can assemble all the materials needed and turn it into a tiny kit to send to a friend who loves sewing. Make a colored photocopy of the chart and key opposite to send with the materials.

CHAPTER 6

Victorian Cards

*T*he Victorians were fascinated by
*papercraft and developed so many
delightful techniques that it is hard not
to look at a delicate piece of découpage
or an intricate quilled card without
thinking of this particular period of
history. An opulent gold border or the
rich colors of the ribbon weaving card
in this chapter can transport you back to
an elegant age when decoration was a
consuming passion.*

*These cards are typical of the much-loved
Victorian era; and in true Victorian style, the
more decorative the better. Clockwise from the
top, here are shown a Lace framed card (see
page 85), a Hand-colored motif card (see page
90), another Lace framed card, a pair of Tartan
Christmas cards (laid flat, see page 87), the
Quilled White on White card (see page 83),
another Hand-colored Motif card and, finally,
the Quilled Frame card (see page 83).*

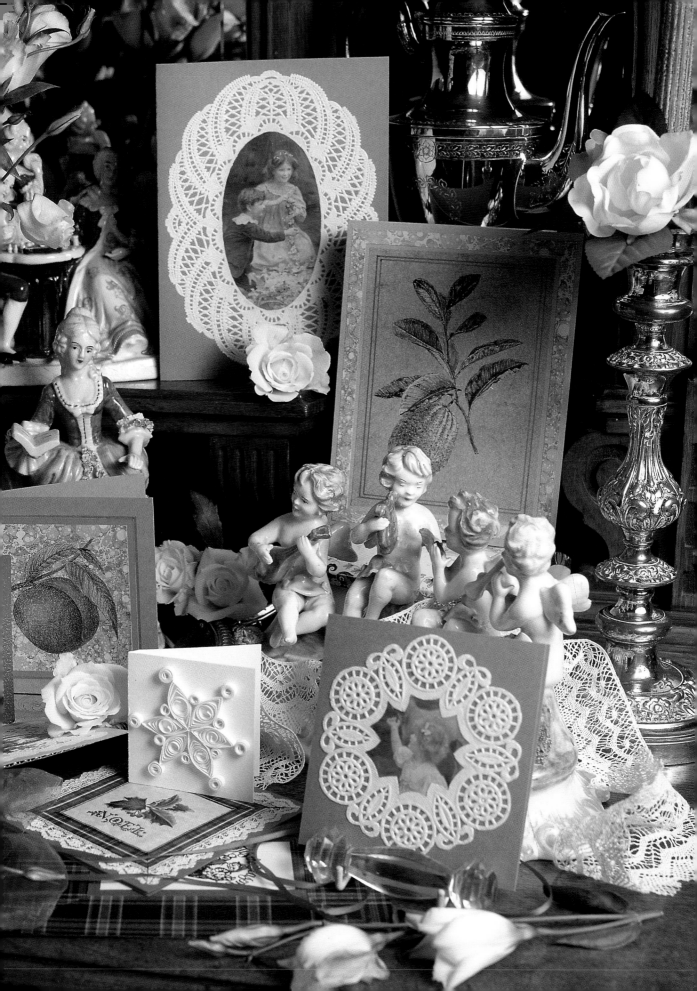

QUILLING

Quilling was a very popular pastime in the Victorian era. Decorative pictures, boxes, tea caddies, and even whole cabinets were covered with these tiny spirals of paper, making intricate patterns and floral designs. Sometimes the paper was colored or gilded to resemble fine gold filigree work. It is an excellent decorative technique to use for greeting cards today, as it is light, surprisingly strong, and inexpensive.

Basic Technique

Before you begin to make a design, here is the basic method for making quilled shapes.

MATERIALS YOU CAN USE
White drawing paper
Quilling tool (or toothpick, narrow dowel, or knitting needle) for rolling the paper strips
Card stock for mount
Clear-drying glue

1 Using a mat knife and cutting board, cut the paper into long thin strips about ⅛ inch wide. The width of each of these should be accurately cut so that the surface of the quilling is level when the design is complete. The next stage is to roll the paper into different-shaped scrolls. The variation in shapes is determined by the length of the paper strip and the way of gluing and pinching each coil before arranging them into the design. Experiment with a few shapes to get the feel of this craft.

2 Starting very near one end of a paper strip, wind the paper firmly around the quilling tool

keeping it level. If you glue the end in place now and then remove the paper from the tool, you will have a closed coil that will remain in this shape. These are very useful for filling in areas and making borders. If, however, you remove the paper before gluing, it will unroll slightly and the layers will open out. Glue the end in place at this stage and you have a simple open coil. This is the most usual method for quilling, enabling you to pinch and shape the coil as follows:

Teardrop

Pinch an open coil at one side after gluing.

Victorians used the beautiful craft of quilling to decorate all manner of items. You could use the quilling shapes to create an attractive frame for a small picture or use them to create a motif that can be glued to a folded card, as shown on pages 78–79.

> ***When you have mastered all the quilling shapes, make a few of each and start to lay them out to form patterns. To make regular designs, you will need to measure each strip of paper and keep it a constant size, so that all the pieces are the same.***

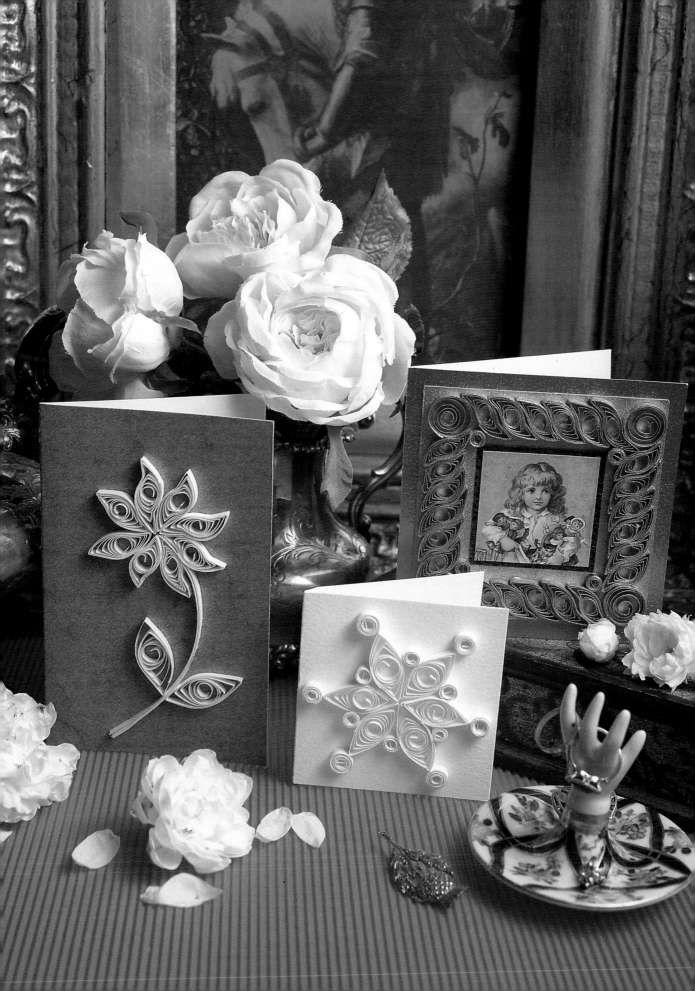

Curled Teardrop

Half moon

Make as for the teardrop but curl the pinched end around.

Press the coil gently around the tool handle and pinch the ends.

Eye

Triangle

Pinch the coil at opposite sides simultaneously.

Fold as for the half moon but pinch the top.

Curled Eye

Square or rectangle

Pinch both sides as for the eye but curl the pinched ends in opposite directions to make a leaf shape.

Pinch two opposite corners, then pinch two more to form either a square or a rectangle. This can also be adjusted slightly to form a diamond.

Flower Card

Using the basic techniques described on page 80 and above you can make the charming flower card shown on page 81 left.

MATERIALS YOU CAN USE
White drawing paper
Quilling tool (or toothpick, narrow dowel, or knitting needle) for rolling the paper strips
6 x 7½ inch blue card stock

1 Fold the card so it measures 6 x 3¾ inches. Make eight curled eye shapes from 12-inch-long strips of paper. Arrange them in a circle to form a flower near the top of the folded blue card. Lift each piece and spread a little glue on the base of the coil. Replace the coil on the card at once, and then glue the next coil in position. Continue in this way around the flower.

2 To make the stem, cut four 4-inch strips of paper and glue them together at one end. Then glue this end between two of the lower petals of the flower. Curve the stem around and glue the other end in place. Make two eye shapes to represent leaves using 12-inch strips and glue them on either side of the stem.

White on White Card

This beautifully patterned quilled card can be seen in the photograph on page 81.

MATERIALS YOU CAN USE
White drawing paper
Quilling tool (or toothpick, narrow dowel,
or knitting needle) for rolling the paper strips
Heavy white watercolor paper

1 Choose a piece of heavy watercolor paper and make a folded card measuring 3¼ inches square.

2 Make six eye shapes from 12-inch-long strips, and glue them in a circle to the center front of your card.

3 Make six closed coils from the same length strips and glue them between the eye shapes. Then make six closed coils from 18-inch long strips, and glue these at the six points to complete the design.

Quilled Frame

When the frame is complete it can be sprayed with gold or silver metallic paint to resemble fine filigree work (see photograph on page 81).

MATERIALS YOU CAN USE
White drawing paper
Quilling tool (or toothpick, narrow dowel, or
knitting needle) for rolling the paper strips
Silver or gold spray paint
Card stock and small motif
Textured mount card 5 inches square

1 Make four open coils from 12-inch-long strips and glue in place at the corners of a 4½ inch square of card stock. Make an equal number of leaf shapes for each side of the frame, using the same length strips. Glue in place to fill the spaces. Finally, make four closed coils from 6-inch-long strips, and glue these at the inside corners.

2 When the glue has dried, spray the whole with silver or gold paint. Spray gently, following the manufacturer's instructions, with several light coats so that the design does not fill in. Cut a square of textured card stock to fit central area of quilling and trim motif to a slightly smaller square. Glue motif to textured square, then glue these inside central area of quilled frame. Glue entire section to front of card mount.

Sometimes it helps to apply a small amount of glue on the sides of the coils as well as the base to adhere the coils to each other. But be sparing with the glue so that it does not show and spoil the finished effect.

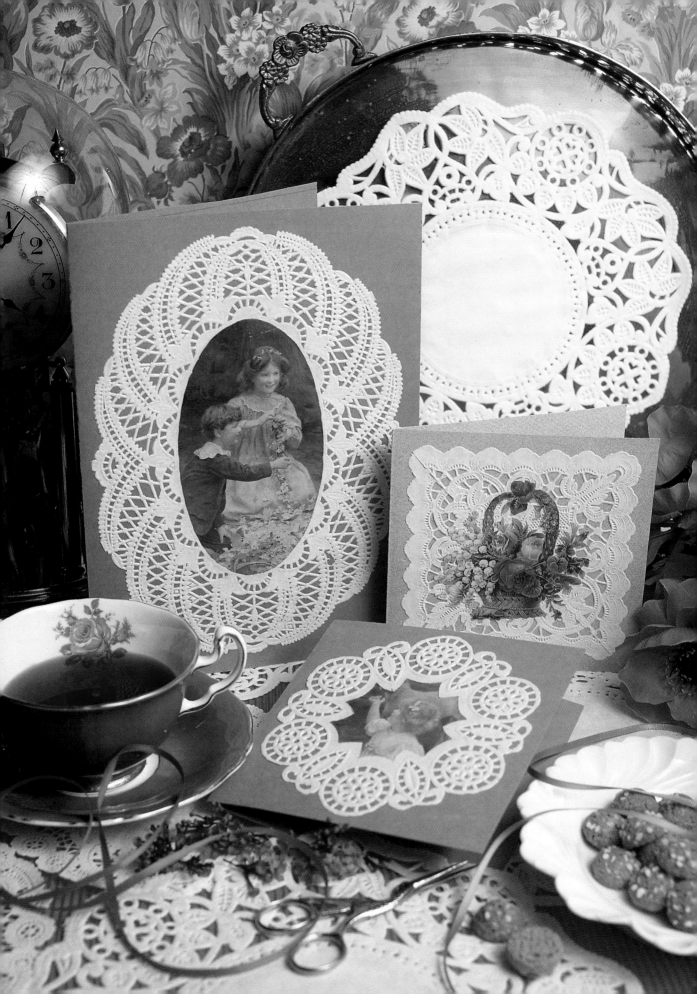

PAPER LACE

Paper doilies and pierced paper decorations make charming Victorian-style cards and mounts. The Victorians loved these intricate, lacy cutouts and used them extensively in designs for Christmas cards and invitations. They used to cut and pierce their own designs from paper, but nowadays we can adapt ready-cut paper doilies to imitate this effect.

Lace-framed Cards

Following the instructions, you can re-create a Victorian-style card. Experiment by laying your lace design on different-colored backgrounds.

MATERIALS YOU CAN USE
White paper doilies in different shapes and sizes
Colored card stock
Suitable pictures cut from greeting cards or magazines

1 Start by selecting a favorite picture or motif. Then decide whether the subject would look better with the lace decoration as an under- or an overmount. An undermount usually looks best when the picture can be cut out from its background and has an attractive and detailed outline. Sometimes a complete doily will work well as an undermount with very few additions. More often than not, however, you will need to trim off certain areas of the doily and add pieces here and there to the edge to make just the right shape. Experiment with lots of different pieces, laying out your design on a colored background until you are happy with it.

You can use delicate paper doilies as an undermount (see examples shown left and bottom), or as overmounts (shown at right). Choose an appropriate design and frame it with the doily to suit.

2 If your design has an undermount, spray glue on the reverse of the doily and lay it in place on the card. Place clean paper on top and press gently to make sure the doily is attached all over. Do not press too hard or you will flatten the embossing.

3 Next, cut out the picture, following the outline and carefully preserving all the details. Spray glue on the wrong side of the image and center it on the paper lace.

For an overmount, lay your picture on a piece of colored card stock and experiment by cutting different center shapes out of several doilies. Lay them on top of the picture to find the best one and trim off edges that overlap too much. Lastly, cut and fold the card stock to fit the mount, leaving a margin around the edge. Glue the picture in place first, then glue the lacy mount.

Another way to use doilies is to cut out lots of small pieces from different doilies. Glue your picture to white or pale-colored paper and then build up an outer frame from the pieces of doily. Work so that the design is symmetrical and the pieces are evenly spaced.

RIBBON WEAVING

This simple weaving technique is most effective when you use varied widths and colors of satin ribbon. Choose about six different ribbons and glue them in a woven pattern onto stiff paper, then enclose them inside a window mount.

Lustrous Heart

A simple heart shape, circle, or diamond makes the ideal window to display ribbons.

MATERIALS YOU CAN USE
A selection of at least six different satin ribbons
5$\frac{1}{2}$-inch square of light posterboard for backing
6$\frac{1}{4}$-inch square of contrasting colored paper
Card stock for window mount (6 x 18 inches unfolded)

1 Trace the inner of the two large heart templates on page 126, then transfer this shape to the center of the posterboard.

Rich reds and deep pinks are the perfect choice for a sumptuous Valentine heart in the Victorian tradition. Adapt your card for any occasion by designing an appropriately shaped window.

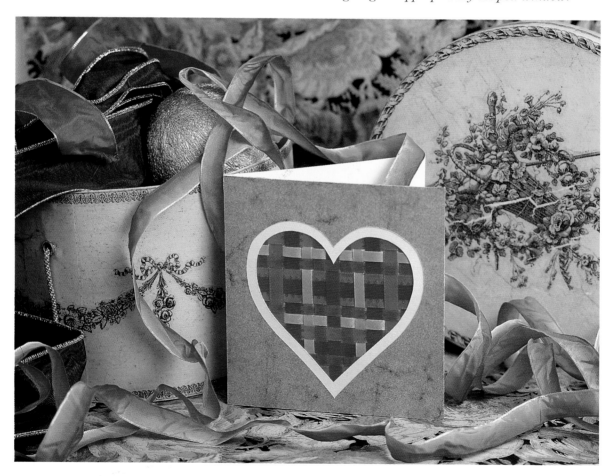

2 Cut several 5½-inch-long pieces of each ribbon. Spray the posterboard lightly with glue and lay strips of ribbon vertically and horizontally, working from the center outward. When you are happy with the placing of the ribbons, lift the ends and weave them under and over each other, pushing the ribbons together so that none of the posterboard shows.

3 Work outward from this in the same way, adding and weaving more ribbons until you have covered the marked area. Tape the ends of the ribbon in place with strips of masking tape.

4 Following the instructions on pages 11 and 12, make a window mount card from the card stock, cutting a heart-shape window using the same outline as on the posterboard. Center the ribbon weaving behind the window and secure in place.

5 To make a border, cut away the larger heart shape (follow the outer line on template, page 126) from the square of colored paper. Glue the square of paper over the front of the card to make a mount that fits around the window. Trim any excess paper at the edge so that the paper is flush with the card.

A TARTAN CHRISTMAS

Tartan was a very popular Victorian theme for Christmas. The cards on page 88 are made with Victorian cutouts, small stamped designs, stars, and gold motifs that have been cut from doilies. The designs are framed with tartan ribbons or giftwrap to give a festive look.

Tartan Borders

Besides being suitable for greeting cards, a tartan border is suitable for gift tags. To dress them up, attach a length of gold cord.

MATERIALS YOU CAN USE
Tartan ribbon or giftwrap
Decorative Christmas stamps, paper cutouts, stars to suit
Card stock in red, green, or white
Fine gold and silver markers
Gold and silver doilies

1 Cut out and fold the card stock to the desired size to make your card mount. Cut four wide strips of tartan ribbon or giftwrap to fit each side of the front exactly. Leave a large enough space in the middle of the card for your central design.

2 Spray the reverse side of the strips with glue and lightly place around the perimeter of the card, level with the outer edges and overlapping at the corners, to form a frame.

3 Using a ruler and mat knife, carefully cut the corners at a 45-degree angle through both thicknesses of tartan simultaneously to make a perfect join (see page 12). Remove the excess pieces at the corners and press the tartan frame in place all around.

4 Use the markers to make one or two decorative ruled borders within the tartan frame. Add shapes cut from doilies, self-adhesive stars, or any stamped or cutout motifs in the center, plus a stamped greeting if you wish.

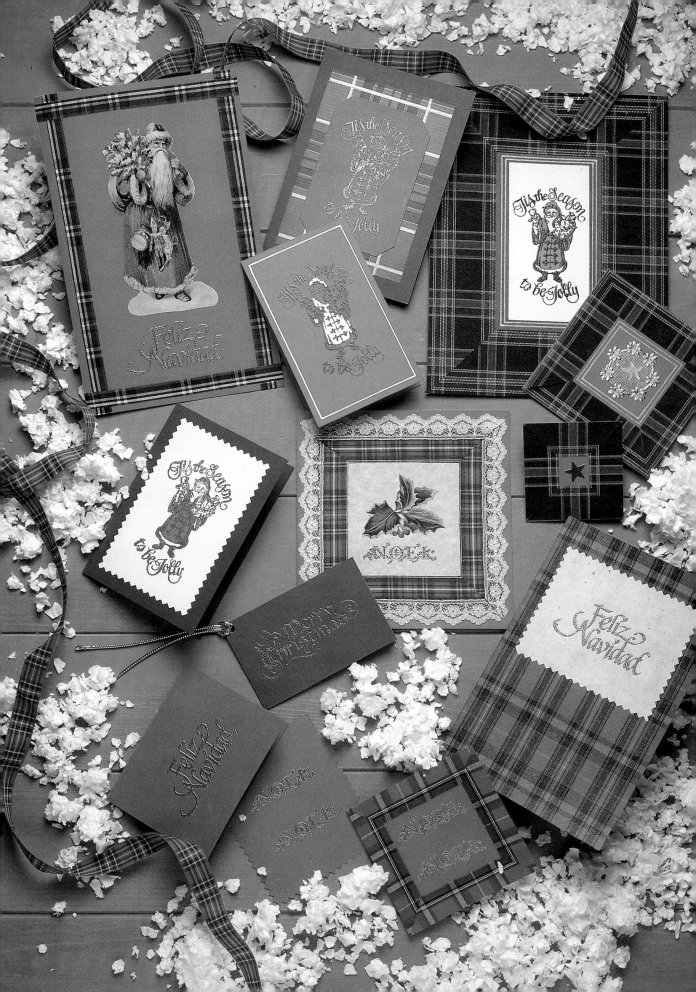

Before cutting out the intricate outer edge of your motifs, cut out any small background areas from the center of the designs, using a mat knife and cutting mat, as the paper will be stronger and less likely to tear at this stage.

5 If you wish, line the inside of the card with white paper (see page 11).

Christmas Stamps

This simple stamping technique, also used to make the attractive star cards pictured on page 55, can be used to create stylish Christmas greetings and gift tags that will be received with pleasure. Victorian-style stamps are available and are ideal for this type of card.

MATERIALS YOU CAN USE
Rubber stamps
Roller
Stamping ink
Colored card stock and fabric

1 Choose gold, green, red, or another Christmas color for your ink. Coat the stamp evenly with ink using the roller as described on page 54.

2 Print onto your background by pressing the stamp down firmly. Either cut out the design with pinking shears or use the hand-torn method described in step 4 on page 11. Attach the motif to a plain mount.

3 To position your stamps accurately on a ready-cut card, follow the instructions for positioning a linocut on page 53.

Embossed Greetings

Embossed Christmas messages, such as those shown on the cards on the facing page, add a very luxurious quality to these easy-to-make cards. You will find it a rewarding task to make festive cards for all your family and friends.

MATERIALS YOU CAN USE
Fine gold and silver markers
Rubber stamps
Embossing ink
Stamp pad
Embossing powder
Colored card stock and paper

1 Cut out pieces of background paper in various Christmas colors to the approximate size you will need, ready for stamping. You do not need to be too accurate with your measurements at this stage as you can simply trim the designs to fit the mounts later.

2 Stamp the motif firmly onto the card, following the instructions on page 54.

3 Add the embossing powder as described on page 54 and heat it until it melts. Use tongs or pincers, if you have them, to keep your hands at a safe distance from the heat source. Spread the

heat evenly under the motif and do not let it overmelt and spoil the design. It is important, however, to make sure that all the embossing powder has melted, otherwise it will brush off.

4 When the embossed paper is ready and the powder has set, cut them out and make them into cards. You can add borders using gold and silver markers (see Tartan Borders page 87).

ENLARGED ENGRAVINGS

Choose decorative fruit, flower, or animal engravings to make these cards inspired by Victorian style. The black and white engravings have been photocopied from a book, enlarged on a photocopier, and then hand colored with inks and colored pencils. The designs are then very carefully cut out and mounted on harmonizing paper.

Hand-colored Motifs

Attach a hand-colored motif to the front of a plain card (see facing page) and add a border.

MATERIALS YOU CAN USE
Photocopied motif (from a book out of copyright)
Colored pencils and inks
Colored card stock
Marbled and colored papers
Fine gold marker

1 Photocopy your motif onto white paper, enlarging it as necessary. Use colored pencils or inks to color in the motif in a naturalistic way. Blend the colors and work slightly over the outer edges. There is no need to add shadows, as the engraving is already shaded.

2 Cut out the motif very carefully, including all the tiny details of leaves, stems, and tendrils. Use a mat knife to remove blank areas, and scissors to trim the edges. Spray the reverse side with adhesive and center the motif on a piece of harmonizing paper, either plain, marbled, or slightly patterned, to enhance the print you have chosen.

3 Trim the edges of the paper into a square or rectangle, leaving an equal space all around the central motif. Draw gold border lines with the fine marker if desired and then center the design on the front of your folded card and glue it in place.

To make a marbled border, cut commercially available marbled paper into strips and miter the corners as described on page 12. Alternatively, make your own marbled paper by filling a shallow tray with water and floating oil-based inks on the surface. Swirl the inks around a little, then lay a piece of high-quality paper on the surface momentarily. Lift it off and allow the paper to dry.

These enlarged hand-colored engravings are evocative of Victorian-style prints. They could even be individually framed; a group of pictures in this style would make a lovely display in a kitchen or dining room.

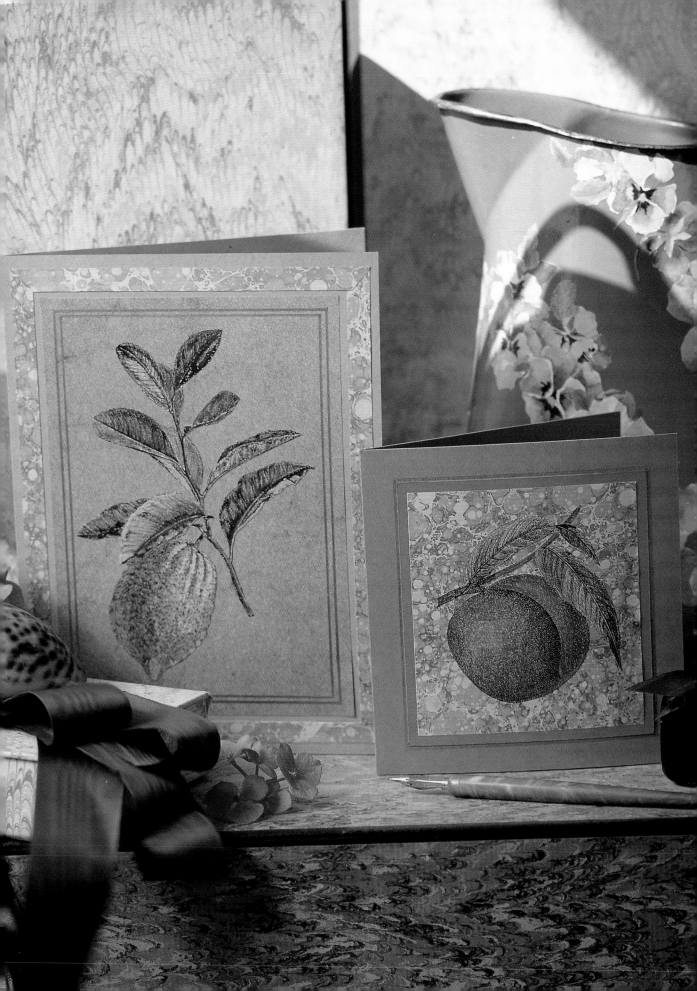

Painted Effects

A variety of different techniques is used in this section—all with startling and dramatic results. The abstract paintings are great fun to make and require no artistic expertise, as the shapes and textures are formed quite accidentally. The ink-blown effect is stunning and is usually achieved by blowing through a drinking straw. Painting on silk and with watercolors produces particularly delicate finishes and makes wonderful backgrounds.

Brightly colored inks and delicate watercolors, applied to a variety of surfaces, make an exciting range of cards. Use the mounts imaginatively to set off your works of art to great effect. For example, the seascape on the bon voyage card is appropriately seen through the porthole of a ship.

ABSTRACT ART

The ink is painted on stretched watercolor paper and then, while it is still wet, creased plastic wrap is laid over the top and left to dry. This forms beautiful, random textures and shapes on the surface.

Splashing colored inks on paper is fun. Experiment by adding texture using plastic wrap, and sprinkling the wet paper with sea salt, and using gold or silver inks.

MATERIALS YOU CAN USE
Watercolor or drawing paper
Drawing board
Sponge
Gummed paper tape
Watercolor brushes
Colored inks in gold, silver, and several colors
Sea salt
Plastic wrap
Colored card stock to make mounts
Fine markers in gold or silver

1 Begin by stretching the watercolor paper so that it will dry flat. To do this, cut the paper so that it is slightly smaller than your drawing board. Wet the paper in a large bowl of water for a few moments. Lift it out and hold it up to allow most of the water to drain off. Then center the sheet on the drawing board and smooth out with the sponge.

2 Tear off four pieces of the gummed paper tape to fit around the edge of the paper.

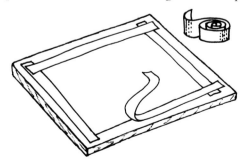

Dampen the back of the tape and apply the tape to the edges of the wet paper to anchor it to the drawing board. Let dry completely flat in a warm room.

3 Using a large watercolor brush, spread various colored inks over the surface of the paper. Use some water to merge the colors and let them run into each other in a random way. At this stage you can sprinkle grains of sea salt into the wet ink, which will create swirling patterns and concentrated areas of color. You can also add splashes of gold or silver ink.

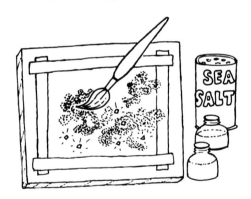

To add texture using plastic wrap, tear off pieces of plastic wrap while the ink is still wet, and place them on the surface of the paper.

You can start by painting one oversize card (opposite, top left), but you can also cut it up to make many smaller cards. Using plastic wrap you can achieve effects like the blue and yellow card (opposite, center), or add rock salt to create an image like the small purple card (opposite, bottom right).

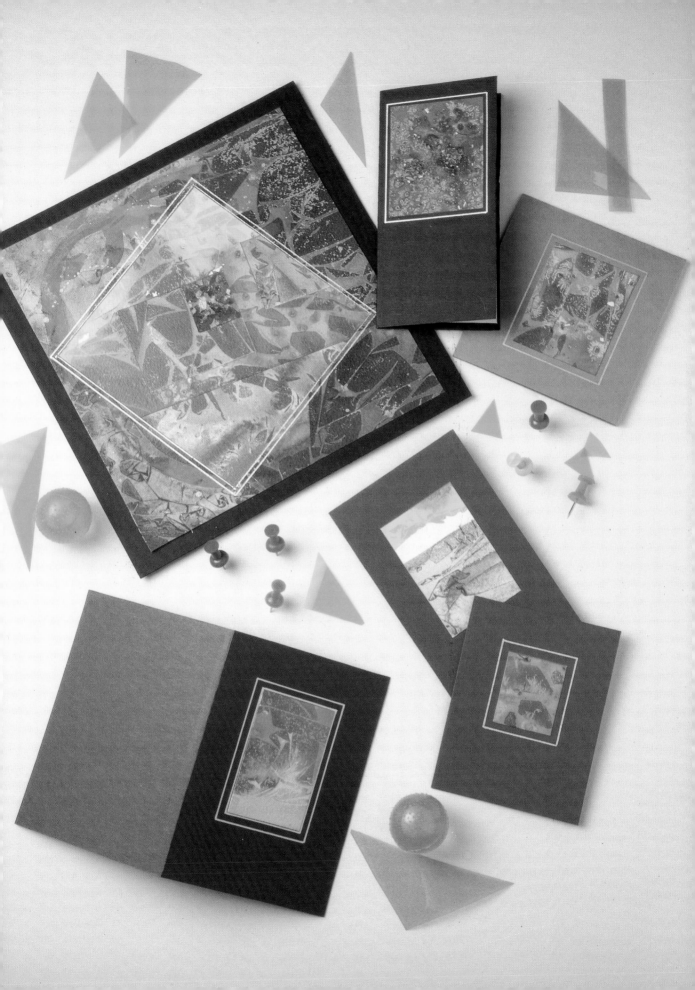

Allow creases to form by gently moving the plastic wrap with your fingertips. When the paper is covered, put the drawing board to one side and leave undisturbed until the ink is completely dry. Do not move the plastic wrap too soon or the pattern will be spoiled.

When the work is completely dry, remove all the plastic wrap carefully from the surface. Cut the paper off the board using a mat knife.

To locate small areas to cutout from a larger painting, you can use L-shaped strips of cardboard. With an 'L' in each hand move about the painting, expanding and contracting the frame. Cut out chosen areas of the design using a mat knife and ruler.

To make the cards, spray the reverse side of your cutout designs with glue and mount them onto card stock. Add metallic ruled borders with a fine marker.

INK-BLOWN CARDS

Another technique using a colored ink background is to place blobs of black ink randomly near the base of your card and then, while the ink is still wet, blow the ink across the surface to create fantastic fairy-tale trees.

Blowing through a drinking straw is the best way to direct the ink and retain some control over the way the trees grow.

MATERIALS YOU CAN USE
Watercolor paper and brush
Drawing board
Sponges
Gummed paper tape
Colored inks in blue, red, yellow, carmine, and black
Drinking straws
Colored card stock to make mounts

1 Stretch the watercolor paper as instructed on page 94, steps 1 and 2. Dip a sponge into clear water and wet the whole sheet of paper again so that when you add the colored inks they will blend together.

2 Dip another sponge into the first ink and spread the color horizontally across the paper, starting at the top. Choose other colors and apply them in the same way, just below the first, using a clean sponge. Continue until the paper is covered and the ink makes a background that looks like a vivid sky. Then let the work dry.

3 Using a large watercolor brush, apply a pool of black ink to the lower area of the paper. Spread this along the bottom edge and add a few more pools of ink to look like tree trunks growing upward.

4 Now, while the ink is still wet, blow through a drinking straw toward the pools of ink. Experiment with different strengths of air and by blowing with the tip of the straw at varying

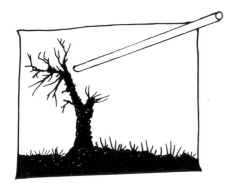

more black ink as you need it and continue blowing until the design is complete.

5 Let the ink dry and then cut up the design into rectangles for your cards. Using spray glue, mount each piece onto a contrasting colored card stock for a dramatic effect.

distances from the surface of the paper. This action will make the ink spread in little rivulets to look like branches on a silhouetted tree. Add

These magical ink trees are created by placing black ink near the base of a card and then, while the ink is still wet, blowing the ink across the surface. Use a vividly colored background for dramatic effect.

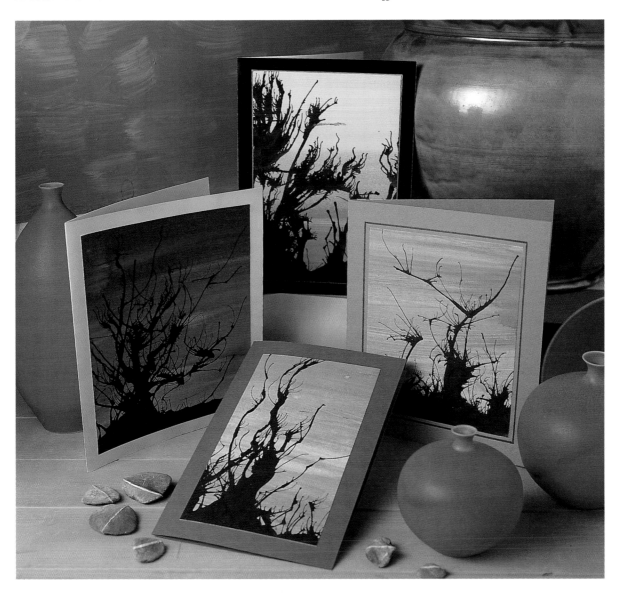

PAINTED SILK CARDS

Bold and simple designs can be traced through the fine silk on which these cards are painted. The fine lines of resist paint create spaces to be flooded with different colors. A variety of effects can be achieved, from stained glass to softly romantic.

Stained Glass

The black outlines and brilliant colors give this card a bold stained-glass effect suited to many occasions.

MATERIALS
YOU CAN USE
Fine black waterproof
marker
Fine white silk, about 7
inches square
Adjustable frame for
stretching the silk
Resist paint in black
Silk paints in red, yellow,
and blue
Thinner for silk paints
Watercolor paint palette
Watercolor brushes
Card stock for window
mount

1 Trace the design at right using the black water-proof marker.

2 Cut the silk slightly larger than the design. Using the frame, stretch the silk. Tape the tracing underneath so you can see the outlines clearly.

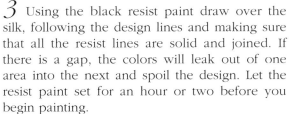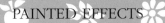
3 Using the black resist paint draw over the silk, following the design lines and making sure that all the resist lines are solid and joined. If there is a gap, the colors will leak out of one area into the next and spoil the design. Let the resist paint set for an hour or two before you begin painting.

A good way of shading the color is to dampen the silk with a brush dipped in clean water and then apply the silk paint on part of the area only. After a few moments, the edge of this brush stroke of color will fade gradually to white.

Painting on silk can create bold, bright areas of color, defined by strong and solid lines as shown below by the Stained Glass card (top). Soft and delicate effects can also be created using exactly the same technique as the Pussycat card (bottom) demonstrates.

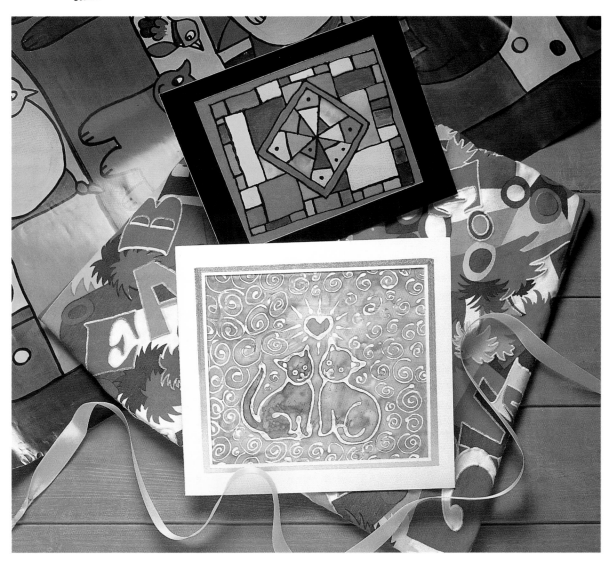

4 Mix the silk paint colors for the design in the palette. Try out each shade on scraps of silk before you paint on the finished article. The colors can be diluted with water or the appropriate thinner for a more pastel effect.

5 To apply even color, load a watercolor brush with silk paint and place it lightly on the fabric in the middle of the appropriate area. Allow the color to creep up to the resist outline gradually

so as not to overload the fabric and possibly bleed into the neighboring area.

6 If you want to darken an area, put a few tiny dabs of darker color in this part while it is still wet. The second coat of color will slowly seep in and create a subtle shaded effect. To add darker lines or spots, let the base color dry and then use a very fine brush loaded with color to paint on the details. Paint very lightly so that the lines do not spread.

7 When the whole design is painted, let it dry naturally in the frame. Remove it next day and fix the silk paints by ironing on the reverse side of the fabric, following the manufacturer's instructions carefully.

8 Tape your finished silk painting to the inside of a rectangular window cut in the center section of a window mount card. Fold over and glue the left-hand section to finish the inside of the card.

Pussycat Card

This charming design (pictured on page 99) is drawn in outline on silk with clear resist paint so that the flat areas can be painted in the colors of your choice. When the colors are dry, the resist is washed out to leave the characteristic delicate white outlines within the design.

MATERIALS YOU CAN USE
Fine white silk, about 7 inches square
Silk paints in pink, gray, and green
Thinner for silk paints
Resist paint in clear
Watercolor brushes
Watercolor paint palette
Adjustable frame for stretching the silk
White card stock for a window mount 7½ x 6¾ inches
Fine black waterproof marker
Silver marker

1 Trace the design carefully from the page opposite using the black marker. Follow the instructions for the silk-painting project in step 2 on page 98.

2 Using the tube of clear resist paint, draw the main design in the center and add the swirling background pattern. Let it set for an hour or two before you begin painting.

3 Mix the colors in the palette and paint your design. Paint the cats and heart first and then mix the background color with some of the thinner to make a pale wash.

4 When the whole design is painted, let it dry, then fix the silk paints by ironing on the reverse side of the fabric.

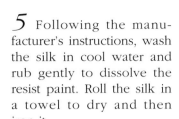

5 Following the manufacturer's instructions, wash the silk in cool water and rub gently to dissolve the resist paint. Roll the silk in a towel to dry and then iron it.

6 Tape your finished silk painting to the inside of a rectangular window cut in the center section of a window mount card. Fold over and glue the left-hand section to finish the inside of the card. Draw a ruled border around the edge of the window using a fine silver marker.

SIMPLE WATERCOLOR CARDS

Watercolor painting (shown on page 103) is quite easy if you follow the simple rule of starting from the top and working downward. Always use a good-quality watercolor paper and stretch it before painting. Let each area of paint dry before you start the next.

MATERIALS YOU CAN USE
Watercolor paper
Drawing board
Gummed paper tape
Small marine sponge
Watercolor paints
Large watercolor brushes
Clean tissues
Colored card stock for mounts
Fine markers in gold and silver

1 Start by stretching a piece of paper slightly smaller than your drawing board as instructed on page 94. Let it dry flat.

2 Using a soft pencil, draw very light lines to create a simple landscape of hills and fields or perhaps a seascape. Use the template on page 102 or a photograph or magazine clipping to help in composing your design. You can paint one large composition or several small ones on the same sheet and cut them up later to make into cards.

3 To paint the sky, dip the sponge into clean water and wet the whole of the sky area of your design. While it is still wet, mix a pale grayish blue watercolor wash and use a large brush to cover the whole area as quickly as possible.

Prepare sheets of different-colored water-color washes to use as mounts in all your card making. The subtle colors and paper texture give an exclusive hand-made look to your designs.

Work from the top of the composition in wide horizontal bands of color down to the horizon. Don't go back over the paint or you will make unnecessary brush marks; but you can add slight changes of color as you go.

4 While the sky is still wet, make clouds by crumpling a clean paper tissue and dabbing it here and there. This soaks up a little of the paint and leaves small white areas to represent clouds.

5 Meanwhile, mix the other colors for your picture. Choose pale bluish greens for the distance and warmer yellow-green shades as you come down the design toward the foreground. Try out the colors on scrap paper, noting that they will dry to a paler shade.

6 Now paint in the hills and fields, working from the top of the picture downward. Let each area dry before painting the one touching it, otherwise the paint will bleed and the colors will merge. You can speed up the process by drying small areas with a hair dryer.

7 When the whole painting is dry, remove it from the board. If desired, you can use L-shaped strips of cardboard to isolate small areas of your design that will make attractive compositions (see page 96).

8 Choose a colored card stock to complement your picture and fold it to make a plain mount. Use spray glue to attach your pictures to the front. Using a ruler and fine marker, draw a border around the edge to complete the card. Glue on a tiny bunch of dried or silk flowers for an added touch.

Bon Voyage

A ship's porthole is an ideal motif to wish someone bon voyage. Paint a watercolor seascape to show through the porthole, as pictured on page 92.

MATERIALS YOU CAN USE
Plain blue card mount
Watercolor paper, brushes, and paints
Mottled gray paper
Silver marker
Folded paper for lining

1 Use a compass to draw a circle on the inside of the front flap of your card. Cut this out carefully using a mat knife and cutting mat.

2 Make the watercolor seascape following the instructions on pages 101–102. Draw a pencil line for the horizon, then paint sky above, let dry, and add a slightly darker blue wash below to represent the sea.

3 When the watercolor is dry, cut a piece of it to fit inside the card, behind the window. Use spray adhesive to mount it on to the lining paper so that it shows through the window.

4 Cut out a ring of mottled gray paper to fit around the window. This could be cut from a watercolor painting or from giftwrap. Use the silver marker to decorate this with lines, dots, and small circles to represent a ship's porthole, and then glue it to the front of the card. Glue the lining into the card to complete.

Small watercolors like these can be cut out of a larger picture or just be a simple wash like a sky with a distant horizon.

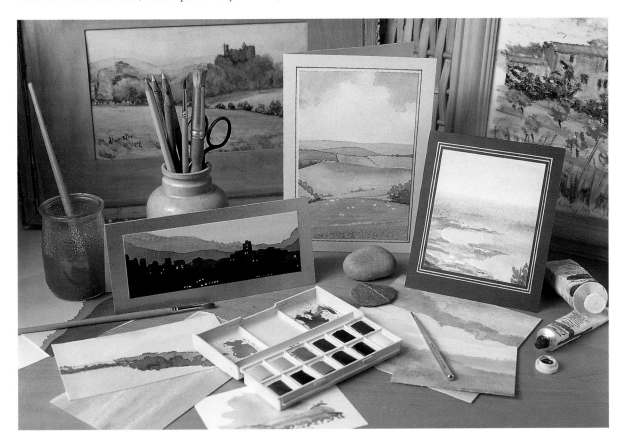

Collage Designs

Collage is a wonderful way to create abstract designs using small pieces of different materials arranged and glued onto a background. There are three types of collage in this chapter: natural, using dried or pressed flowers, feathers, or shells; paper, using everything from the finest tissue to corrugated cardboard, cellophane, and metallic foils; and fabric, using scraps of iridescent silk, tiny prints, lace, ribbon, beads, and cord.

Choose printed, patterned, metallic, and textured papers that are as varied as possible from the wonderful selection in art supply and specialty paper stores. Dry your own flowers or press them, and collect swatches of beautiful fabric, braids, ribbons, and lace to create a card from this delightful selection or to make unique gift tags.

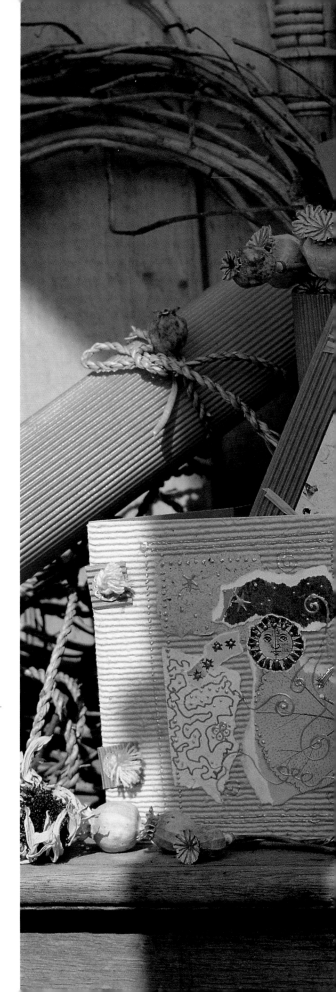

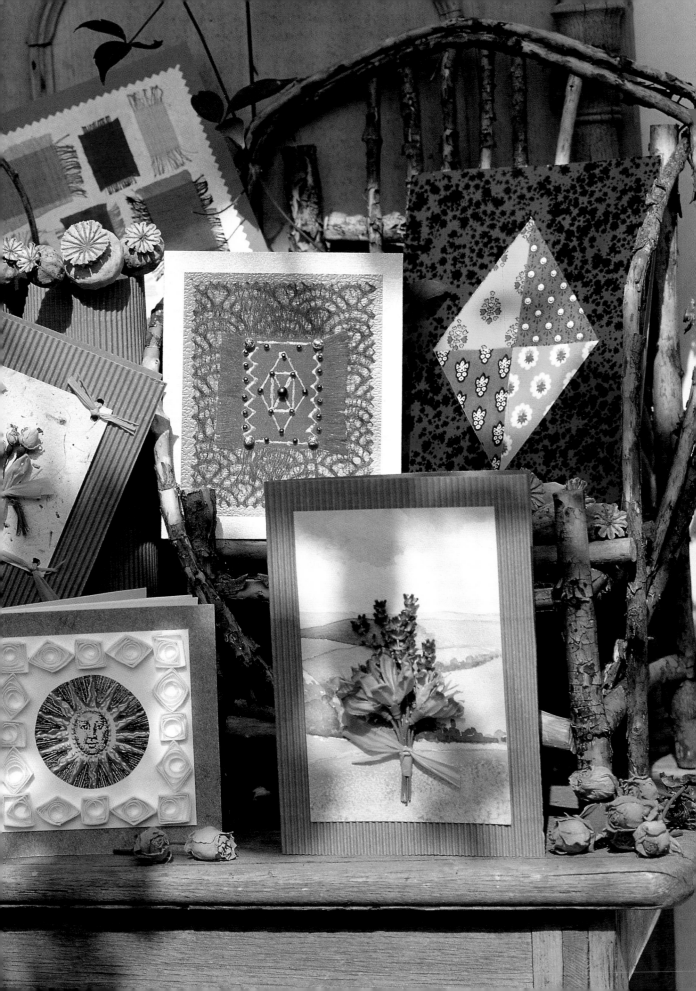

NATURAL COLLAGE

Collecting shells and drying and pressing flowers and leaves are charming pastimes. But when these treasures are carefully arranged on the right background, they make cards that can bring lasting pleasure to a friend or relative.

Dried Flowers

Choose a warm, dry day to select your flowers; and experiment drying different varieties.

MATERIALS YOU CAN USE
Fresh flowers and leaves for drying
Low-temperature glue gun and glue sticks
Raffia or ribbon
String
Assorted papers and corrugated cardboard

1 Pick most flowers and sprigs of statice and lavender at the height of their season, choosing a warm, dry day. Select flowers that are not quite in full bloom, as they will continue to develop slightly while they are drying. Experiment drying different flowers and you will soon find the perfect moment to pick each type of plant so that it dries looking its best. Rosebuds are a little more flexible as to the precise moment of picking. But try to choose ones in which the color of the petals is quite obvious and the green sepals have opened and are drawn back. Tiny wild rosebuds dry very well and are perfect for a miniature nosegay.

2 To dry the flowers, strip off most of the leaves, tie the stems loosely with string and suspend them near the ceiling of a warm room. The time it takes to dry out will vary with different flowers, but touch is the best way to tell when they are ready. They should feel quite dry and papery, and the stems will be hard and brittle.

3 Cut the flower stems fairly short and tie them into a tiny flat bunch with a bow made with raffia or ribbon. Choose your backing paper and glue the flowers in place with a glue gun or white glue. Glue or punch holes and tie your arrangement to the front of the folded corrugated cardboard card to complete.

When sending a card to a friend, consider selecting a flower associated with their birth sign.

AQUARIUS
Orchid, goldenrod

PISCES
Water lily

ARIES
Honeysuckle, thistle

TAURUS
Rose, poppy, foxglove

GEMINI
Lily-of-the-valley, lavender

CANCER
Acanthus, lily, all white flowers

LEO
Sunflower, marigold

VIRGO
Buttercup, forget-me-not, all small bright-colored flowers

LIBRA
Large roses, hydrangea, all blue flowers

SCORPIO
Geranium, rhododendron

SAGITTARIUS
Pinks, carnations

CAPRICORN
Pansy, ivy, hemlock

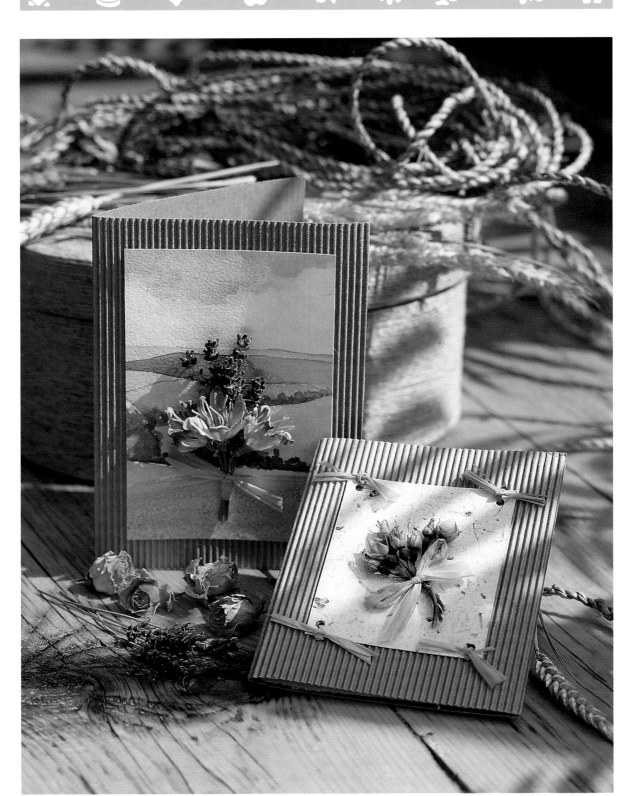

*Try your dried flowers on a variety of colored backgrounds until you find just
the right blend of tones, textures, and colors.*

Pressed Flowers and Leaves

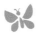

Gather together your selection of flowers, perhaps choosing the favorite blooms of the person you are making the card for, and place them inside a sheet of folded blotting paper for pressing.

MATERIALS YOU CAN USE
Fresh flowers and leaves for pressing
Raffia
String
Assorted papers and card stock
Watercolor brushes
Large heavy books or flower press
Sheets of clean blotting paper
Tweezers

1 Collect the flowers on a dry day after any dew has dried completely. Select several of the same type of blooms, a few buds, and some small pieces of foliage. The most successful pressed flowers are those that grow fairly flat on the plant and so do not become too distorted when pressed. Yellow, mauve, and blue flowers keep their color better than some others, but it is still worth trying pink and red ones, even though they tend to discolor after a while. Colorful autumn leaves can also be used.

2 Carefully cut the flowers from the stems and leaves and lay them out inside a sheet of folded blotting paper. Arrange the blooms on the sheet, leaving space for them to flatten out. Arrange the foliage and stems on another sheet. Fold the

These collage cards use both natural materials and paper cutouts. Clockwise, from top right, you have pressed leaves (see above), shells (see page 110), dried rose buds (see page 106), a combination of a cutout paper sunflower and pressed leaves (see page 111), two cards featuring pressed flowers (see above), and a simple cutout paper flower design (see page 111).

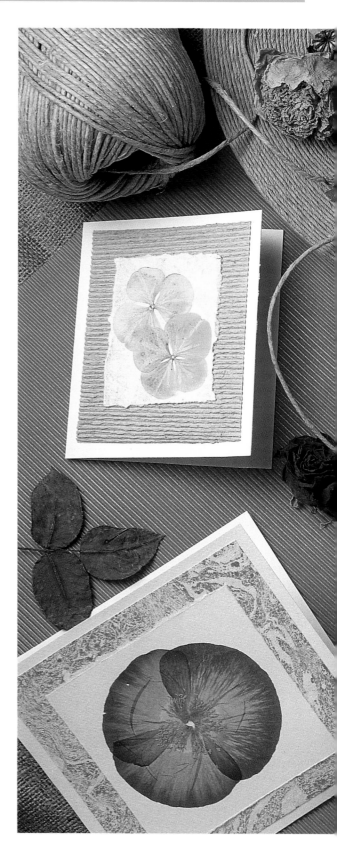

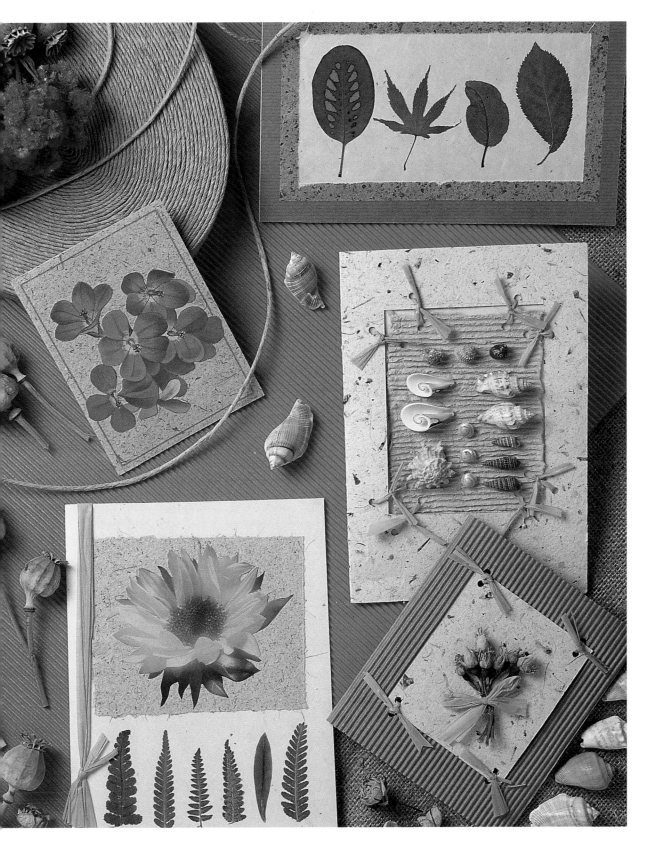

blotting paper over to enclose the plants and put them between the pages of a book. Pile more books on top to weight it down and leave for about three weeks to dry out. Check after this time, carefully opening the blotting paper so as not to tear the fragile petals. If the flowers are papery and flat and they come away from the blotting paper easily, they are ready; if not, they may need another week or two to dry out before you can use them.

3 Pick up the flowers with tweezers and lay them on your selected paper background. Move them about with a dry brush. When you are happy with the design, lift a petal here and there

and dab a little glue underneath to hold it in position. You can use spray adhesive on the back of petals and leaves for a more secure arrangement or even protect your designs with clear self-adhesive plastic. Add a touch of gold paint applied with a fine brush to subtly colored flowers like hydrangeas.

4 Try your finished arrangement against different colors of card stock until you find just the right blend of tones, textures, and colors. Fold the card then use spray adhesive to mount it onto the front of the folded card. Add any drawn border lines at this stage to decorate, or tie in a lining paper with a strand of raffia or string.

Seashells

A selection of beautiful little shells can be collected during a walk on the beach. Try to gather as many as you can if you do not visit the seashore very often; then you can take shells from your collection whenever you are making a greeting card. Once you have decided on the arrangement of shells, attach them with glue to a complementary backing.

MATERIALS YOU CAN USE
Small shells
Low-temperature glue gun and glue sticks
Raffia
String
Window mount and corrugated cardboard
Watercolor brushes

1 Choose a selection of tiny seashells and arrange them on the cardboard. When your design is ready, use the glue gun to attach the shells securely to the backing.

2 For a charming, natural effect, you can punch holes around the edge of the backing card at each corner and match them up with holes punched around a cutout window on your folded card mount. Lay the piece of cardboard inside the window and then tie it in place using pieces of raffia or coarse string to finish the card.

PAPER COLLAGE

The wonderful selection of papers available is inspiration itself, and simply cutting or tearing up pieces to arrange in colorful compositions makes paper collage an easy and enjoyable craft.

Scrap Paper Collage

The cards shown on page 112 are ideal for a beginner, as you can use pretty scraps left over from other projects. Cut the pieces into shape and mount them onto the front of a folded card.

MATERIALS YOU CAN USE
Scraps of painted backgrounds, giftwrap, and white and colored card stock
Gold and silver relief outliners
Card stock for plain mount

1 Using pinking shears, scissors, or a sharp knife, cut the pieces of painted background into small squares and rectangles. Arrange these to create the design on a piece of card stock or stiff giftwrap and then glue them in place.

2 Use spray adhesive to glue the design to the front of a folded card in a suitable color. Use the outliners to draw on motifs, lines, and rows of dots to decorate the pieces.

Flower Cutouts

Printed flowers can be glued onto backgrounds to make quick cards (see pages 108 and 109).

MATERIALS YOU CAN USE
Gold relief outliner
Printed flowers from magazines or giftwrap
Pressed ferns or leaves
Papers and card stock for plain mount

1 Choose your printed flowers and cut them out carefully using small sharp scissors. Follow the outlines, including as much detail as possible.

2 Try the flowers on various types of card stock and choose the one that looks best. Cut out a plain mount from this and use spray adhesive to glue the paper flowers in place. Alternatively, glue the paper flower onto a background paper and attach this to a card mount.

3 Finish the card with ruled borders or a row of tiny pressed leaves and a raffia tie.

Handmade and textured papers look particularly good with hand-torn, rather than cut, edges. To do this successfully, lightly mark the area with a pencil line and then lay a metal ruler along the inside of the line. Press down firmly with one hand on the ruler and pull the strip of excess paper sharply along the ruler edge to tear it neatly. This will leave a slightly uneven edge which follows the texture of the paper. This is perfect for linear shapes, but if you want random-shaped pieces simply tear by hand and let the paper dictate the shape.

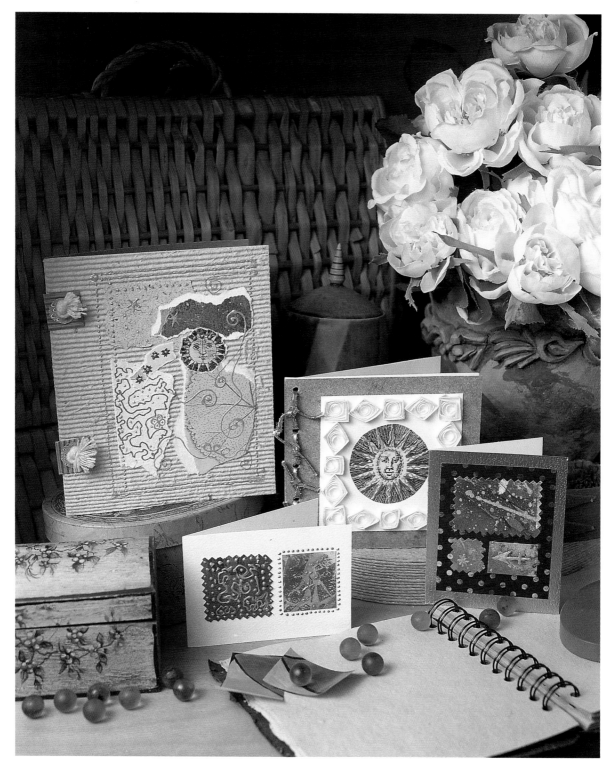

A variety of collage techniques and finishes are shown here. From left to right, you have a Torn Natural Paper Collage card (see opposite), a small Scrap Paper Collage card (see page 111), a Modern Quilling Motif card (see opposite) and a second Scrap Paper Collage card (see page 111).

Modern Quilling Motif

Use the quilling technique (pages 80–82) to make a Mexican-style frame for a modern-looking card with a sun motif.

MATERIALS YOU CAN USE
White watercolor paper
White drawing paper
Scraps of giftwrap
Gold relief outliner
Colored card stock
Narrow gold braid

1 Cut out a 4-inch square of white watercolor paper. Following the quilling instructions on page 82, make sixteen square shapes from ⅛-inch-wide and 12-inch-long strips of drawing paper.

2 Glue four quilled squares at the corners of the watercolor paper. Glue another four squares at the center of each side of the paper. Compress the remaining squares into diamonds to fit between the squares. Glue these in place to complete the frame.

3 Choose a motif from giftwrap or another source and glue this inside the quilled frame. Decorate with gold outliner and glue the whole piece to a square of harmonizing card stock. Cut another piece of the same card stock to this size for the back.

4 Place the front and back pieces together with right sides outside and punch five equally spaced holes down the left-hand side. Measure where you want the holes before you start. Tie the cards together with pieces of gold braid threaded through the holes. If desired, include two hole-punched lining sheets at the same time.

Torn Natural Paper Collage

Hand-torn natural-colored paper, arranged artistically on a textured background looks particularly effective when decorated in gold relief (see opposite).

MATERIALS YOU CAN USE
Scraps of various handmade and natural-colored papers, giftwrap, tissue, and card stock
Corrugated cardboard
Gold relief outliner
Heavy cord

1 Tear about five pieces of handmade and natural-colored paper into random-shaped pieces. Arrange these on corrugated cardboard to form a good composition and use spray adhesive to glue them in place. Choose a small motif like a sun or flower from giftwrap or another source and glue this in position.

2 Use the gold outliner to draw tendrils, stars, lines, dots, and borders to decorate your composition. Trim the corrugated cardboard so that the design is placed slightly to the right of the piece. Cut another piece to the same size for the back of the card. Place them together and punch two holes down the left-hand side.

3 Cut out two small squares of dark corrugated cardboard and two small circles of patterned paper. Punch a hole in the center of each to make washers. Using a piece of cord, thread the back and front of the card together so the ends of the cord are at the front. Thread on the square, then the round washer, and knot both ends of the cord. Trim excess cord.

Paper Magic

These fun cards, pictured below, are a fast and simple way to send details of a baby's birth. Tear thin paper into simple shapes to make the design of your choice. Glue them in position on a plain card mount.

MATERIALS YOU CAN USE
Thin paper colored on one side
Colored card stock
White paper

1 Draw your shapes very lightly in pencil on the thin colored paper. Choose different-colored paper for each component of the design. Tear the paper to make the shape you have drawn, leaving a random white border all around the edge.

2 Using spray adhesive, glue the shapes, overlapping each other, to the front of the folded cards.

3 Make linings of white paper slightly smaller than the cards. Then, either handwrite the baby's details or greeting on each one or photocopy your message from a master copy.

Using thin paper in several different colors, tear out the desired shapes to make a composite picture. Mount on brightly colored paper for a fun finish.

FABRIC COLLAGE

Carefully chosen, arranged, and mounted, even the tiniest scraps of fabric can make a greeting card to treasure. Fray the edges into a luxurious fringe, add beads, braids, and stitchery, and you have a tiny work of art in fabric.

Baby Bootie

Use a pretty baby's bootie card to make a birth announcement or a birth congratulations card. You could make the card in the appropriate pink or blue, if you choose.

MATERIALS YOU CAN USE
Scraps of braid, lace, cord, and ribbons in pastel colors
Pink or blue card stock

1 Score and fold a 5 x 10-inch piece of pink or blue card stock in half across the width. Using the template on page 127, trace the bootie

shape; place the dotted line against the folded edge of the card. Draw around and cut out the bootie.

2 Use scraps of lace, ribbon, and braid to decorate the front of the bootie card. Cut the pieces roughly to length, glue in place, then trim level with the edge of the card using scissors.

3 Take a piece of pink or blue cord and tie into a bow. Dip the ends into white glue to prevent unraveling. Glue the bow to the front of the bootie.

Silk Mosaic

Arrange and glue tiny swatches of iridescent silk into the colorful fabric mosaic shown on page 117.

MATERIALS YOU CAN USE
A selection of scraps of iridescent silk
Gold-patterned paper
Card stock for mount

1 Cut a selection of vividly colored silks into small squares and rectangles. Fray the edges of each to fringe them and then arrange them on a piece of gold-patterned paper.

2 When you are happy with the composition, pick up each piece (you may find it easier to use tweezers to do this), spray the reverse side with adhesive, and press in place on the card to build up the design. Cut the paper into a rectangle with pinking shears, leaving a border around the fabric pieces.

3 Mount this design onto the front of a plain mount in a suitable color, to complete your greeting card. Trim the edges of the card to leave an equal border all around.

Provençal-Print Diamond

The bright Provençal prints used in this simple patchwork diamond (facing page) captures the spirit of the South of France.

MATERIALS YOU CAN USE
Scraps of four different Provençal or other prints
Blue patterned window mount

1 Cut the fabric scraps into 4 x 2¾-inch rectangles. Stitch one blue and one yellow piece together along the long sides, with right sides together. Press the seam open, then stitch the other two pieces together in the same way, this time reversing the colors.

2 Lay the two joined pieces together, right sides facing, and line up the center seams exactly. Stitch these together and press the seams as before.

3 Cut a diamond-shaped window in the center section of the card using the template on page 126.

4 Tape the fabric patchwork behind the diamond window and fold over and glue the left-hand flap in place to hide the back of the fabric.

Oriental Carpet

A small square of vivid red silk, beads, lace, and gold relief outliner make a card that looks like a rich Eastern carpet.

MATERIALS YOU CAN USE
Scrap of red silk
Scrap of dark paper lace
Beads
Gold relief outliner
Gold textured card stock
Plain silver card mount

1 Fray a piece of red silk as for the mosaic card on page 115 and mount this onto a piece of

paper lace using spray adhesive. Mount both of these onto a piece of textured gold card stock and trim the gold card to leave a narrow border around the edge.

2 Mount the fabric collage onto the front of the folded silver card. Using the gold outliner and the photograph as a guide, draw lines onto the red silk. Add in some dots, and while the outliner is still wet, press on some beads. Make a diamond shape in the center and larger dots of outliner at the corners. Press more small and large beads in place to decorate.

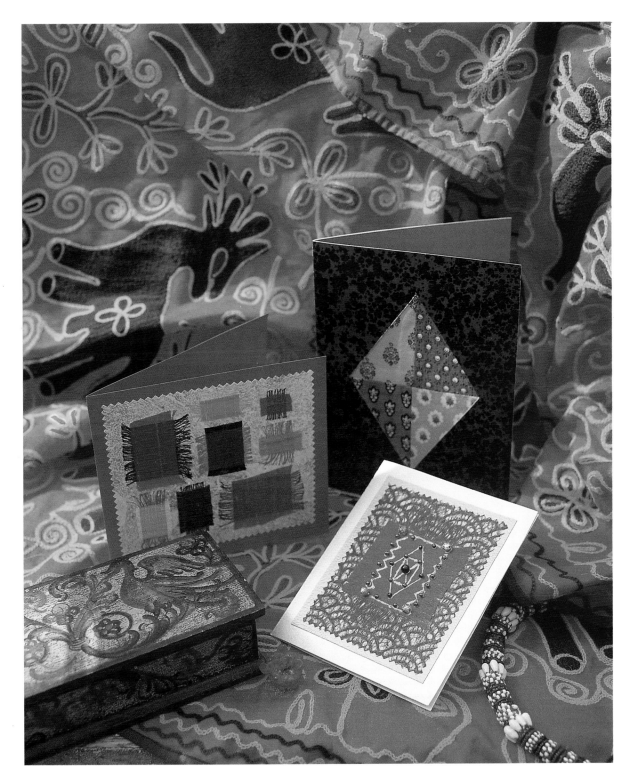

A variety of fabric collage cards is shown here. At the top right there is a stitched patchwork Provençal-Print Diamond card (see opposite), and below this is the Oriental Carpet card (see opposite) decorated with gold relief outliner and beads. To the left of these is a simple Silk Mosaic card (see page 115).

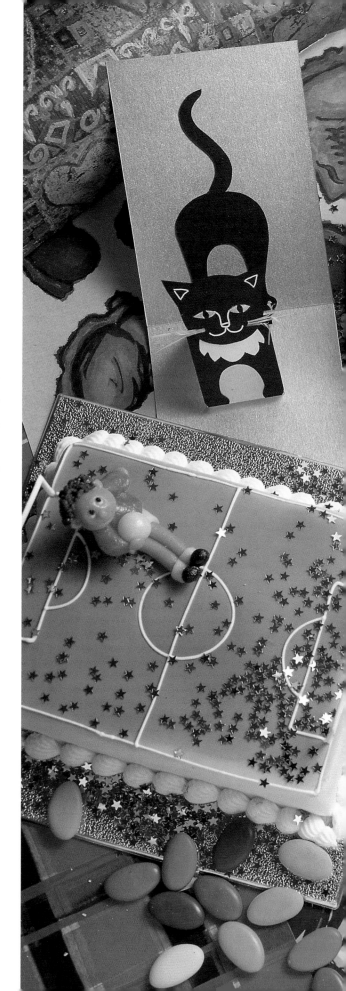

Novelty Cards

A *novelty card can double as a gift
and makes a perfect greeting for
any member of the family, from the
puzzle fanatic to the sports fan. You
could even delight a sweet-toothed friend
with an edible card. From pop-up cats to
a birthday cake card, the following fun
ideas are easily adapted to suit the
occasion.*

*Here is a selection of ideas for novelty cards.
Clockwise, from top right, there is the Edible
Flower card (see page 121), the Sneaker card
(see page 122), the Edible Owl card (see page
121), the Jigsaw Puzzle card (see page 125), the
Pop-up Cat card (see page 123), and the
Birthday Cake card (see page 122).*

EDIBLE PLACE CARDS

These cards look good enough to eat! Made from wafer-thin sheets of edible rice paper and decorated with food coloring, they can be used as party place cards.

MATERIALS YOU CAN USE
Sheets of edible white rice paper
Food coloring
Readymade floral cake decorations
Flying-saucer or other large round candies
Fine watercolor brush
Pieces of narrow ribbon
Confectioners' sugar and egg white
Fine black marker
Paper for lining

Edible rice paper is brittle, so the cards are best if made with an outer and an inner sheet to give them strength. The thin sheets are translucent, so you can trace through them.

Owl Card

1 Carefully fold a sheet of edible rice paper in half without splitting it. To do this, lay a ruler where the fold should be, dip the watercolor brush in clean water, and paint a line along it. While this line is still damp, fold the paper carefully so that it does not crack. Place the card under a book to dry.

2 Take a piece of tracing paper at least twice the size of the half-owl pattern at right and fold in half. Place the fold on the dotted line and trace the pattern. Turn the paper over and trace the other half to make the complete shape. Slip the tracing inside the folded rice paper card and trace the shape through the rice paper onto the outside of the card using green food coloring and the fine brush.

3 Choose two green flying-saucer candies or other suitable large pale-colored candy and draw eyes on them with the food coloring. Mix some confectioners' sugar with a little beaten egg white to make a thick paste. Apply this icing with the tip of a small knife to the back of two candy "eyes" and press them onto the rice paper card. Let it dry flat.

4 Make a lining from another piece of rice paper, write your message using food coloring, and slip it inside.

Flower Card

1 To make the edging on the larger card, cut the edge of the outer sheet of wafer paper with pinking shears. Then color in the points of the zigzags with red food coloring and the fine brush to make a decorative border.

2 Draw the basket, flower stems, and inner border freehand. Use icing (see step 3 opposite) to attach the readymade flowers and leaves. Slip the lining piece inside each card and tie the layers together with a piece of narrow ribbon finished with a bow.

Children, or indeed anyone with a sweet tooth, will enjoy the edible rice paper flower place card (left) and owl place card (right).

BIRTHDAY SURPRISES

A selection of delightfully unusual card designs for fun lovers everywhere. Each of these cards has a built-in surprise.

Birthday Cake Card

Send a cake card with real candles—to celebrate a birthday (shown on page 119).

MATERIALS YOU CAN USE
Silver paper lace edging
Gold cake candles
Colored plain mount
Stiff and patterned papers
Scraps of metallic hologram paper

1 Cover a 4 x 2¾-inch piece of stiff paper with patterned paper and glue a strip of paper lace across the center. Cut the long top and bottom edges of the "cake" with pinking shears.

2 Attach transparent tape to the short ends on the wrong side. Fold the tape back on itself and

press to the front of the mount so it curves away from the surface to look like a cake.

3 Glue the candles to the card across the top of the cake. Tuck the base of each candle just below the top edge of the "cake."

4 Cut flame shapes from hologram paper and glue them onto the card behind each wick. Mail the card in a padded envelope to protect it.

Sneaker Card

Send this fun card (see page 119) to a sports fan or to a small child who's learning to tie shoelaces.

MATERIALS
Shiny and matte black card stock
White card stock
Silver marker
Scraps of patterned paper in red and blue
Shoelace

1 Trace the shoe template from page 127. Transfer the outline onto the front of a folded plain mount made with matte black card stock, lining up the dotted lines with the folded edge. Cut the shape out and draw the outline of the inner sole with a silver marker.

2 Using the tracing, transfer and cut out the white, patterned, and shiny black parts of the design. Glue the zigzag shape and the lower end of the tongue in place onto the shaped card mount.

3 Glue the blue patterned pieces onto the white sides of the shoe, then punch the holes. Use the silver pen to draw the stitching and around the holes. Insert the shoelace (being careful not to smudge the silver) and tie a bow. Spread glue around the edges of the back of the shoe upper and press it onto the card mount, over the tongue section.

4 Glue on the heel support and toe cap. Finally, draw the remaining lines of stitching in silver.

Pop-up Cat

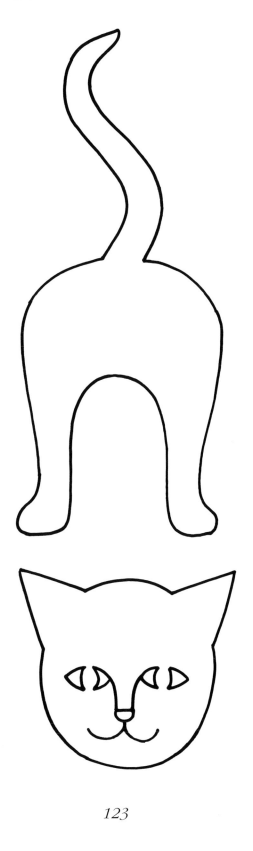

The friendly black cats on pages 118 and 124 will bring good luck to the person receiving these cards.

MATERIALS YOU CAN USE
Silver card stock to make a pop-up stand
Matte black card stock
Scrap of white card stock to make cat body
Scraps of metallic hologram paper
Small piece of raffia
Silver marker

1 Cut a piece of the silver card stock measuring 4½ x 13 inches. Score across the width on the reverse side and fold in half so the silver is on the inside.

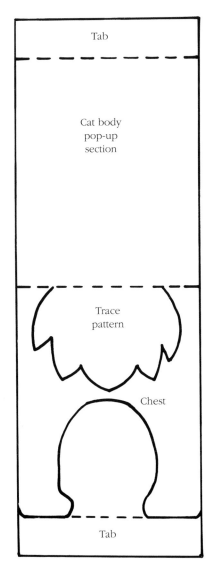

2 Trace the shapes on the previous page. Cut out the pop-up stand from silver card stock; the cat's head and front and back legs from black; the chest from a contrasting color; and the eyes from hologram paper.

3 Glue the back legs, centered, to the inside of the card so that the feet touch the inside fold.

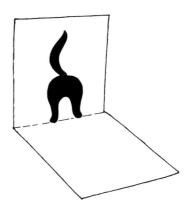

Write a greeting on the back of the jigsaw card (bottom) so it can be assembled and read. Adapt the pop-up card (top) to make other animals.

4 Glue the front legs to the cat's body section and score along the dotted lines to make tabs. Fold these tabs under and spread with glue. Fold

the stand in half along the center dotted line, and place the piece inside the card, lining up the back of the body with the back legs so the cat will stand up when the card is opened. Press the tabs firmly to glue securely.

5 Glue the chest piece in place. Draw the cat's features in silver and glue on the eyes. Cut two pieces of raffia and glue onto the cat's face. Shred the ends of the raffia to make whiskers. Glue the head onto the body.

Jigsaw Puzzle Card

Please someone you know who's always wanted a sports car with this jigsaw card (opposite).

MATERIALS YOU CAN USE
Picture to use for jigsaw
Fine marker
Piece of posterboard
Fine sandpaper
Card stock to make box
Double-sided tape

1 Make a reduced color photocopy of the picture and set it aside. Cut out the original picture, spray the reverse side with glue, and press it onto the posterboard. Let the glue dry, then trim the edges to make a rectangle. Write your message on the back.

2 Draw the shapes of the jigsaw pieces on a piece of tracing paper the same size as your picture. Place it over the picture and go over the lines firmly with a hard pencil. Cut along the indented lines using a mat knife and cutting mat.

3 Using sandpaper, smooth any rough edges. Roll the sandpaper into a narrow tube to sand the curved slots slightly so they will fit well.

4 For the base of the box, follow the diagram and draw the shape to the required size on the card stock. Cut along the solid lines and score along the dotted lines on the right side of the

card stock. Fold along the scored lines to form the sides of the base. Fold in the corner pieces and secure them with double-sided tape.

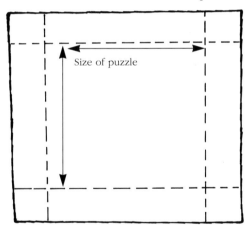

Size of puzzle

5 Make the lid in the same way, but cut it slightly larger to allow it to slip over the base. Glue the photocopy of the completed jigsaw to the center of the lid.

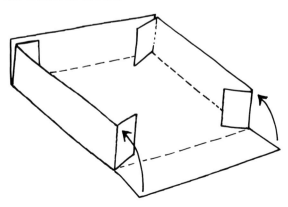

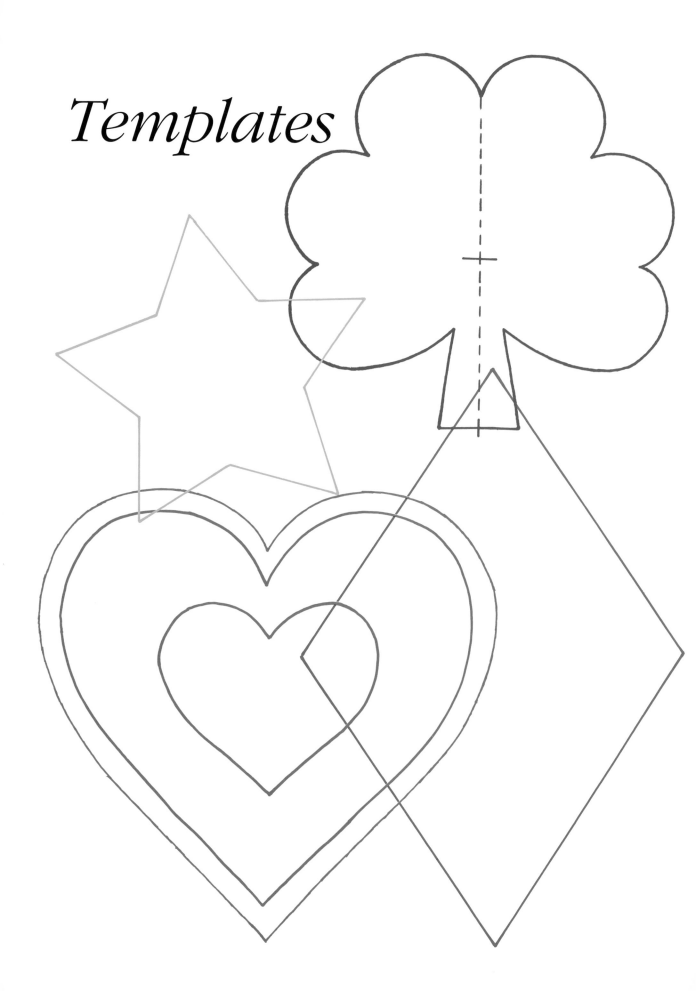

Templates

PLACE ON FOLD

PLACE ON FOLD

PLACE ON FOLD

PLACE ON FOLD

Index

Page numbers in *italic* refer to illustrations.

Acetate sheet, 41, 57, 58
Adhesives, 8 and *passim*
Aida fabric, 68, 69

Backing fabric, 71, 73
Bar mitzvah cards, 41–2
Beading/molding, 15
Beads, 39, 40, 73, 116
Birth announcement, 58, 114, *114*, 115
Birthday cards, *16–17*, *18–19*, 22, 26–9, 122–5, *124*
Bon voyage card, *93*, 103
Bookmark, as gift, 25, *26–27*
Bootie, 115
Borders, 9, 11, 12, 36, 70, *70*, 87, 90; mitering, 12, 89; spring flower, *2*, 64, *65*; zigzag, 63, 64
Braid, 115

Candies, 120, *121v*
Candles, 122
Card stock, 8 and *passim*
Cartoons, 24
Change of address card, 50–1, *51*
Christmas cards, 32–6, *33*, *35–6*, 89–90
Collage, 32, *33*, 104–17, *104–5*, *112*; fabric, 115–17, *117*; natural, 106–10, *107–9*; paper, 111–14, *114*
Cord, 113, 115
Cutout cards, 20, *21*
Cutting out, 8, 89

Daisies, *66*, 67
Doilies, *84*, 85, 87

Edible cards, 120–1, *121*
Embossing, *48–9*, 54, 89–90
Embroidery, 11, 12, 60–70, *60–1*, *69*, *70*, 74–7, *75–6*; ribbon, 62–7, *65–6*
Engravings, 90, *91*
Envelopes, 8–9, *9*, *10*
Equipment, *6–7*, 8

Fabrics, 11, 32, *33*, 115–17, *117*
Flowers, dried, 104, 106–10, *107–9*
Fourth of July card, 46, *47*
Fusible web, 68

Gift tags, 87, 89
Glue gun, 8, 106, 110

Hearts, *2*, 43–5, *45*, 68, *68–9*, 86–7, *86*
Holder, card, 14–15, *14*

Inks, 13, 25, 43, 52, 54, 59, 89, 94–6; blown, *2*, 96–7, *97*
Invitations, 13, 51–3, *53*, *56*, 57
Ironing, 34, 68, 100, 101

Jigsaw puzzle card, *124*, 125

Keepsake, 69–70, *70*
Knife, mat, 8, 80, 89, 125

Lace, 115, 116; paper, *84*, 85
Lettering, 13, 24; transfer, 13
Lining, 9, 11, 20, 89, 120, 121
Linoleum cuts, 52–3, *53*

Marbling, 90
Markers, fiber-tipped, 9, 11–13 *passim*, 34, 43, 46, 47, 54, 59, 73, 89, 90, 94, 98, 100–3 *passim*, 122, 123, 125; food-coloring, 129
Mat, cutting, 8, 89
Mineral spirits, 43
Motifs, 24, 54, 89, 90, *91*, 113
Mounts, 9–12; under, 10, 11, 85, *85*; window, 9, 11–12, *11*, *12*

Needlepoint, 74–7, *75–6*
New Year's cards, 37–40, *38*; Chinese, 40; Divali, 37, *38*; Jewish, *38*, 39–40
Number cards, 13, 18, *19*

Outliner, 20, 24, 25, 32–4, 39–42 *passim*, 73, 111, 113, 116

Padding, 9, 44–5, *45*, 69
Paints/painting, 13, 41–2, 92–103; abstract, 94–6, *95*; silk, 23, 34, 36, *36*, 98–101, *99*; stencil, 57, 58; watercolor, 23, 34, 101–3, *103*
Paper, 8, 9 and *passim*; drawing, 80, 82, 83, 94, 113; giftwrap, 9–11, 34, 43, 87, 111, 113; hologram, 37, 122; marbled, 9, 11, 39, 90; edible rice, 120–1; watercolor, 25, 94, 96, 101, 103, 113; wrapping, 8
Paper lace edgings, 34, 122
Particleboard, 8, 77
Patchwork, 71–3, *72*, 116, *117*
Pencils, 13, 41
Pen, calligraphy, 13
Photocopying, 13, 90,125
Plastic wrap, 25, 94, 96
Pop-up card, 123–5, *124*
Positioning, 53, *53*, 89
Potato cuts, 50–1, *51*
Printing, 13, *48–59*, *48–9*; computer, 13; mono-, 43, *58*, 59

Quilling, 79, 80–3, *81–2*, *112*, 113

Raffia, 111, 123, 125
Religious cards, 41–2, *42*
Resist paint, 23, 34, 44, 45, 98–101 *passim*
Ribbon, 9, 15, 115, 121; embroidery, 62–7, *65–6*; tartan, 87–90, *88*; weaving, 86–7, *86*
Right-angle triangle, 8, 11, 77
Roller, 10, 43, 52, 54, 59, 89
Roses, 64–7, *66*
Ruler, 8, 11, 77, 111

Sea salt, 94
Sewn cards, 43–4, *45*. *See also* embroidery
Shamrocks, 46–7
Shells, 110
Shoelace, 122
Silk, 23, 44, 73, 116, *117*; mosaic, 115; painting, 23, 34, 36, *36*, 98–101, *99*
Stained glass, 41–2, *41–2*
Stamps, *2*, 13, *16–17*, 24, 54–5, *55*, 89–90
Stars, 32, 34–6, *35–6*, 46, 71–3, *72*; burst, 46, *47*
Stenciling, 13, *56*, 57–8
Stitches, chain, 63; cross, 68–70; half cross, 74; French knots, 63; lazy daisy, 63; ribbon, 63; stem, 63; tent, 74, basketweave, 74
St. Patrick's Day card, 46–7
Stretching, 34, 77, 94, 96, 98, 101
Sun card, *16–17*, 20, 21
Sweets, 120, *121v*

Tape, 25; masking, 42, 53, 87
Tassel, 18
Tearing, paper, 11, 34, 55, 89, 111, 113, 114, *114*
Teddies, *2*, *17*, 23
Templates, 50–1, 126–7
Tension, stitch, 62, 77
Tracing, 32, 37, 39–41 *passim*, 46, 111, 113, 114, 120, 122
Tree, Christmas, 32, *33*; of life, *22*, 23

Valentines, 43–5, *45*, 68, 69

Washers, protective, 113, *113*
Washing, 101
Wax, sealing, 24
Wedding cards, *56*, 57
White glues, 8, 15, 106, 115

Zodiac cards, 25–9, *26–7*